EAST BRIGHTON
& OVINGDEAN
THROUGH TIME
Douglas d'Enno

AMBERLEY PUBLISHING

For David Baker
1940-2008

First published 2010

Amberley Publishing Plc
Cirencester Road, Chalford,
Stroud, Gloucestershire, GL6 8PE

www.amberley-books.com

Copyright © Douglas d'Enno, 2010

The right of Douglas d'Enno to be identified as the
Author of this work has been asserted in accordance
with the Copyrights, Designs and Patents Act 1988.

ISBN 978 1 84868 904 6

British Library Cataloguing in Publication Data.
A catalogue record for this book is available from
the British Library.

Typeset in 9.5pt on 12pt Celeste.
Typesetting by Amberley Publishing.
Printed in the UK.

Introduction

This volume is intended to be a companion to my *Rottingdean Through Time*, published by Amberley in 2009, and to complement *Brighton Through Time* by Judy Middleton, which also appeared in that year. Inevitably, there will be some overlap with the latter volume but there is no duplication of images and similar ones are usually viewed from a different angle – in images and words.

As far as I am aware, this is the first book devoted to East Brighton, even if Ovingdean does account for a third of the content. So where exactly is the area? One local historian whom I asked remarked that it was 'wherever I wanted it to be'! I was obliged to adopt this recommendation to some extent but trust that my readers agree with the western boundary selected, namely Rock Gardens (and Madeira Drive east of that point, imagining a line extending down to that lower level), Egremont Place, Queen's Park Road, the top of Elm Grove, Warren Road, Bevendean Road (so as to include the old hospital) and Lewes Road bordering Moulsecoomb. The eastern boundary is clear-cut, represented by the village of Ovingdean up to the Falmer Road.

Woodingdean, well covered by fellow-local historian and friend, Peter Mercer, is excluded from this volume.

The 'three thoroughfares' of Chapter 1 are those major parallel roads running from west to east in what is predominantly Kemp Town, i.e. Madeira Drive, Marine Parade and Eastern Road (with a brief foray into St George's Road).

The selections of images in this book have been determined by the 'old' images located by me in 2009/10, many of which, however, have not been published previously in any book on Brighton. Some are inaccessible to other writers, having been provided by my own contacts. Another deciding factor has been whether a given scene has altered to any extent. Hence a number of notable streets and buildings, such as Sussex Square, Lewes Crescent and the former French Convalescent Home at Black Rock have been deliberately omitted since they have changed little.

The apparently isolated village of Ovingdean is by no means as detached from East Brighton as might be thought. Its parish area was formerly vast, extending as far as, and including, the land now covered by the Whitehawk estate. There are also many strong

personal connections between the village and (East) Brighton: Magnus Volk is buried in Ovingdean churchyard and here too is to be found the family vault of the Beards, who owned Sheepcote Valley and the farmland which became the East Brighton Golf Course. The Cowley family farmed from Black Rock (admittedly in Rottingdean parish) and transferred to Ovingdean, occupying The Grange for some years.

My own credentials are a series of articles I wrote for the weekend editions of *The Argus* in 2000/2001 resulting from my personal interest in Ovingdean's history. In publishing terms, it is high time that part, at least, of a book should be devoted to the village to complement *In Living Memory*, the valuable oral history produced in 2000 and edited by Jennifer Drury, which is regrettably no longer in print.

Douglas d'Enno
Saltdean, August 2010

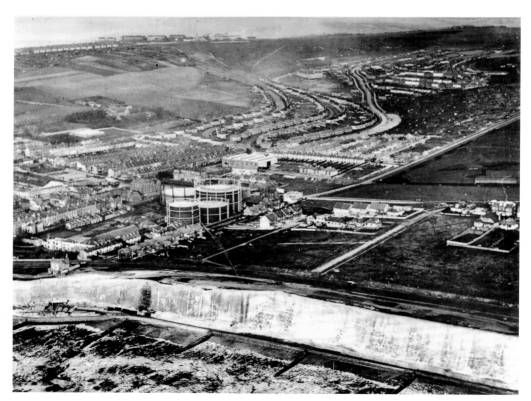

The Black Rock area and beyond in the 1930s (Fred Netley Collection).

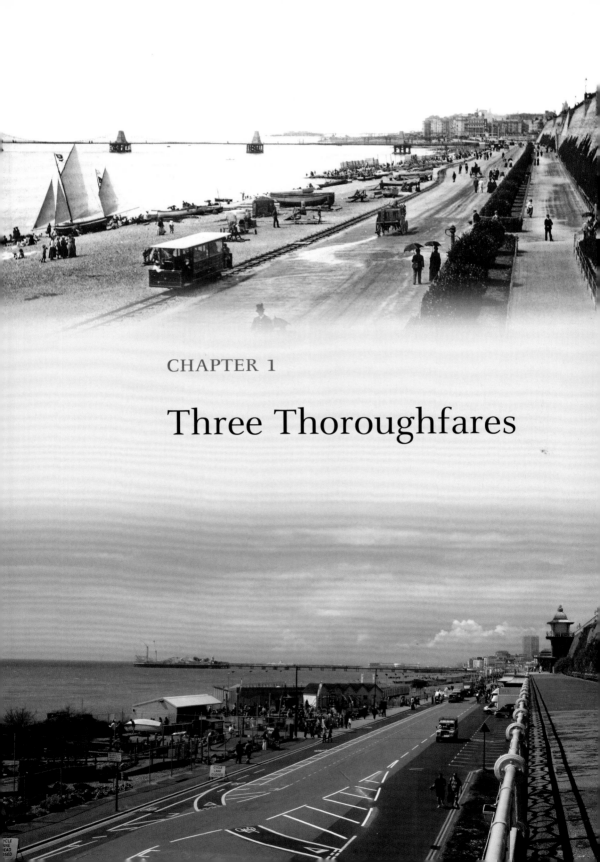

CHAPTER 1

Three Thoroughfares

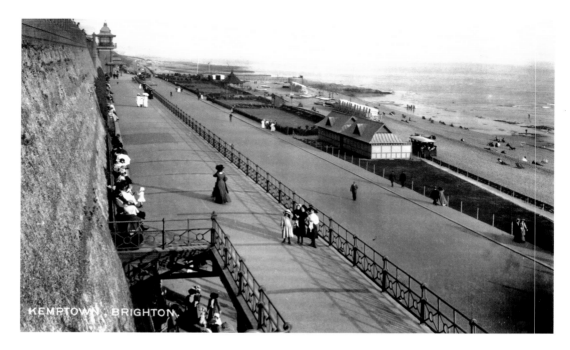

Madeira Drive looking East

Madeira Drive, at the foot of the East Cliff, was created in the early 1870s and called Madeira Road until 1905. Work on the terracing began in 1890, when the lift in the distance opened, and continued in stages until 1897. Closed in 2007, the lift was reopened in April 2009 following a £250,000 restoration but has been temperamental. The photograph contrasting with the atmospheric Victorian view on the previous page was taken from the eastern end of Max Miller Walk.

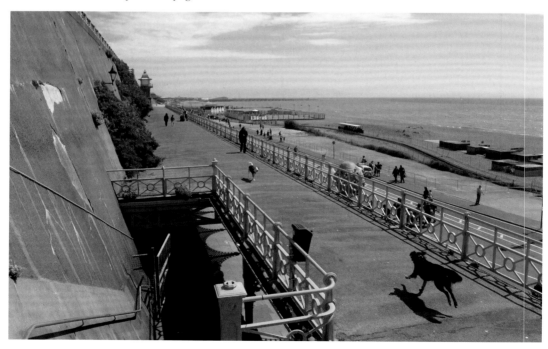

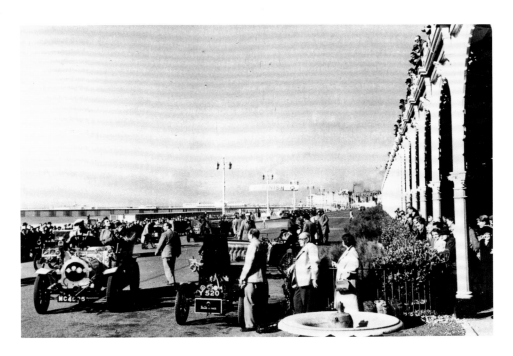

The Motor Road

The London to Brighton Veteran Car Run is the longest-running motoring event in the world. The first run took place in November 1896 and has taken place most years since then. *Genevieve* (above left), a 1904 Darracq which still participates each year at the time of writing, is seen in Madeira Drive in a lobby card for the much-loved 1953 film named after the car and starring Kenneth More and Kay Kendall. The Brighton Speed Trials have been held since 1905 on Madeira Drive. On 12 September 2009, the black Mazda RX-7 driven by Andrew Embling (placed eleventh in class) heads the line-up for the start.

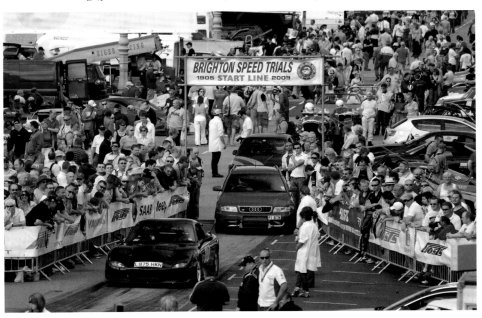

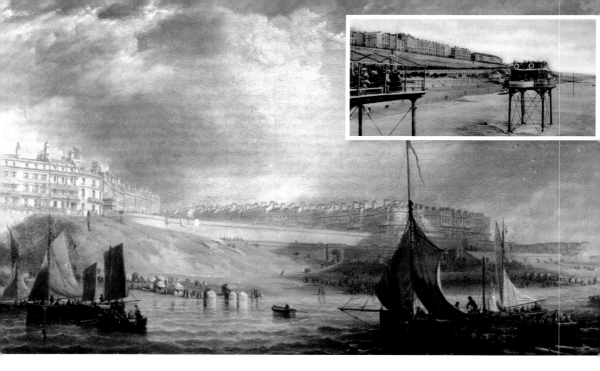

From Sail to Rail

John Wilson Carmichael (1800-1868) has left us a fine record of part of the Kemp Town estate, developed overall between 1823 and 1855, in his oil on canvas *Kemp Town from the Sea*, dating from 1840. The façade of Lewes Crescent in the background was completed in 1827. Magnus Volk's 'Sea-going car to Rottingdean' (inset), designed to run on a seabed track from Paston Place to Rottingdean, enjoyed only a brief existence (1896-1901). The concrete groynes built east of the town cut into the trackbed at many points and forced the closure of the railway. Volk's Electric Railway (below) however, is still going strong and is the oldest electric railway in the world, the first section having been completed in August 1883.

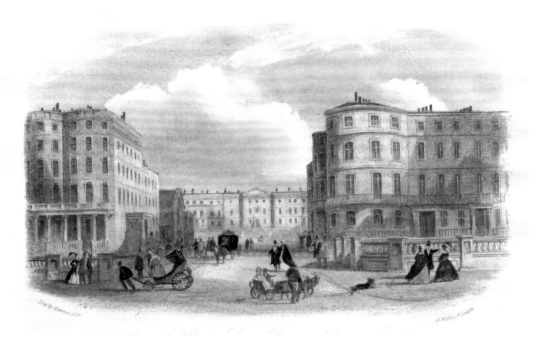

Off Marine Parade (1): The Bristol Hotel/Bristol Court/Bristol Arms

Newman & Co. of London engraved this delightful view showing the Bristol Hotel (left) in Marine Parade in around 1845, 10 years after it opened. Its builder, William Hallett, named the hotel after the fifth Earl and first Marquess of Bristol, for whom he had built 19 and 20 Sussex Square. Hallett also constructed the RC Church of St John the Baptist in Bristol Road, founded the Kemp Town Brewery and became Mayor of Brighton in 1855. Part of the building is today the Bristol Arms bar and the rest is the Bristol Court apartments.

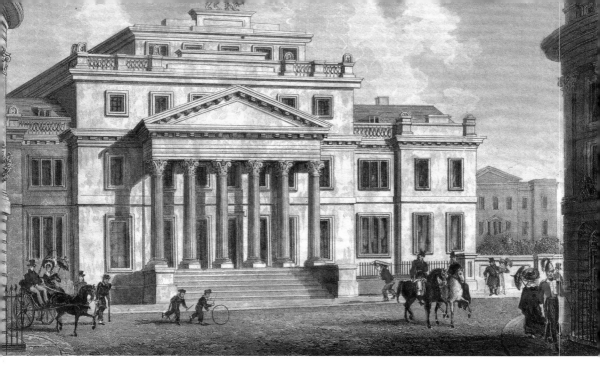

Off Marine Parade (2): Portland House and Place

Wealthy Major Villeroy Russell of 53 Marine Parade developed Portland Place but his own grand mansion at the north of it was destroyed by fire, on the night of 12 September 1825, even before completion. It was eventually replaced by 12-14 Portland Place, namely West House, Portland House and Portland Lodge respectively. In January 1847 Brighton College began its life at No 13 and remained there until the premises in Eastern Road – see page 15 – were ready for occupation. Today, Sussex House, a specialist NHS Trust medical centre and nursery, stands on the historic site in St George's Road.

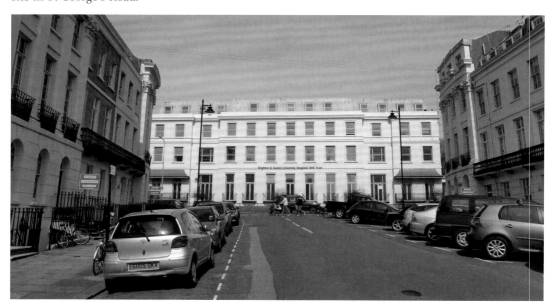

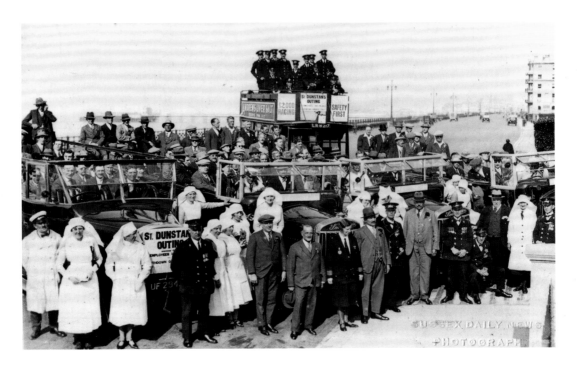

On Marine Parade (1): A Special Outing

On an unrecorded date in the late 1920s (the vehicle on the left was new in 1928), the residents of nearby St Dunstan's and their carers line up for a splendid group photograph. The charabanc-type vehicles in the foreground are all Tilling-Stevens B9Bs with locally-built Harrington bodies, all delivered to Southdown Motor Services between 1926 and 1928. The open-top bus full of drivers in the background is thought to have been new in 1910 and acquired by the company in 1918. Below, Marine Parade at a quiet moment on 1 May 2010.

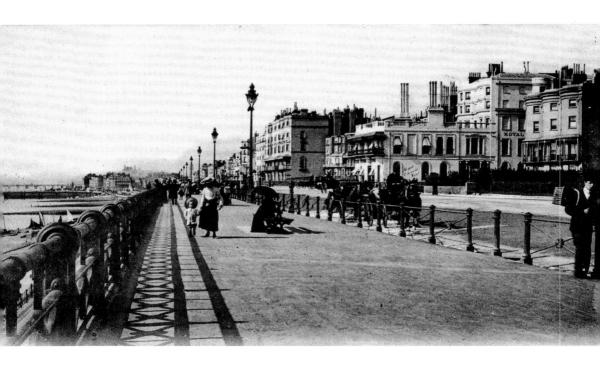

On Marine Parade (2): the Strollers' Walkway

Marine Parade, again looking west. The Bedford Street to Paston Place section of this major road was laid out in 1822-1830. Dominating the background above is the Royal Crescent Hotel, now the listed five-storey Royal Crescent Mansions. The first two storeys were built in the early nineteenth century as a private house, lived in at one stage by statesman George Canning (1770-1827), who was Prime Minister briefly in the last year of his life. Conversion to a hotel took place between 1848 and 1857.

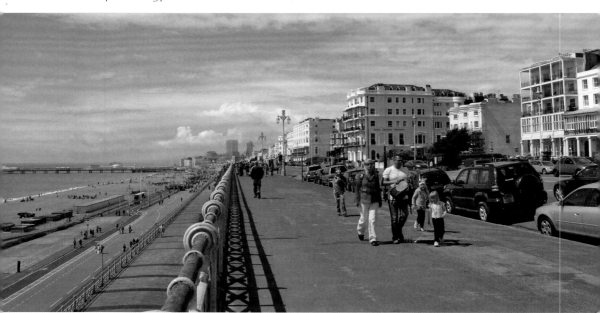

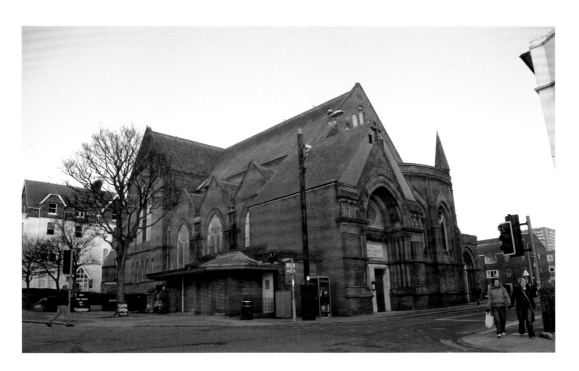

St Mary's – a Church Reborn

In Upper Rock Gardens/Upper St James's Street stands the church of St Mary the Virgin. It occupies the site of the former St Mary's chapel, designed by Amon Henry Wilds and built in 1827 for Charles Elliott in the grounds of East Lodge, the home of the Earl of Egremont (visible in the background of the etching below made in around that year by Edward Fox). It was said to be a replica of the Temple of Nemesis in Athens. Due to faulty workmanship, however, part of the roof and walls collapsed during essential repairs in 1876. The present church was designed by William Emerson and dedicated to St Mary. It was erected in 1877-9 and can hold up to 800 people.

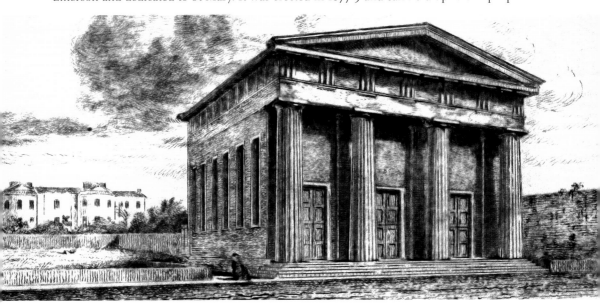

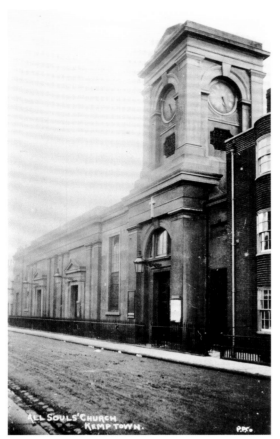

A Lost Church on Eastern Road

All Souls' Church was designed in plain classical style by Henry Mew and built in 1833-34 for the Revd Henry Wagner to serve a poor area of the town. In 1879 Edmund Scott remodelled the interior and four years later it became a parish church. In 1903 and 1906, stained-glass windows by Charles Kempe were added, some of which are now in Norwich Cathedral. In 1967 the parish merged with St Mary and St James, where there is now a chapel dedicated to All Souls, but the latter church was declared redundant and demolished in January 1968. Central in today's view is the rear of Hereford House Care Home.

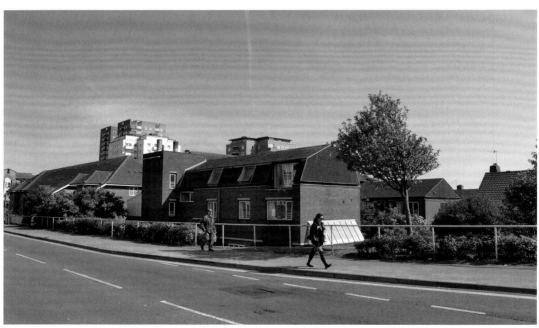

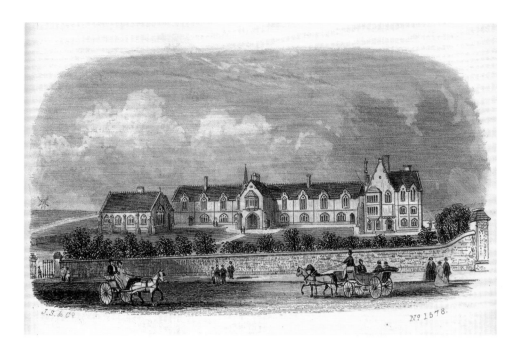

Brighton College

This fine tinted print of the College, founded in 1845 by William Aldwin Soames, dates from between 1859 (when the Chapel on the left was built) and around 1865. The Principal's house on the far right, designed by Gilbert Scott, had been put up in 1852-53. It provided accommodation for boarders and living quarters for the Principal's family. The most significant change in the modern view is the extension of the Chapel. This addition dates from 1922/23 and was built as a memorial to former pupils who fell in the First World War.

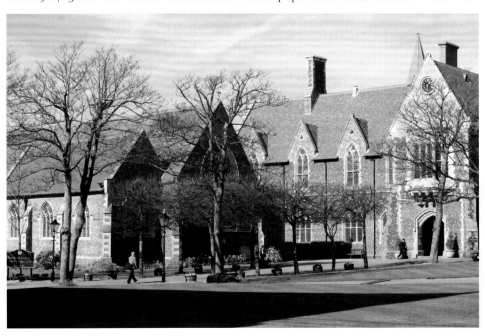

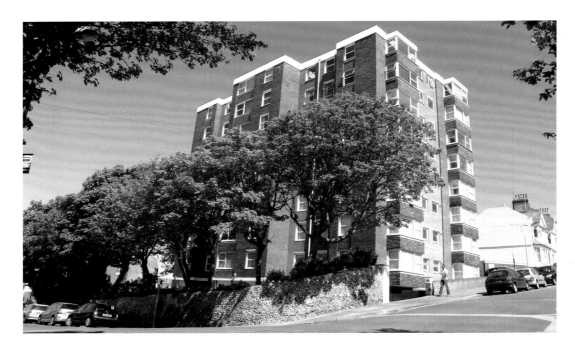

The Name Lives On: Belle Vue

Belle Vue Court, consisting of forty-one flats on seven floors, was erected in Belle Vue Gardens, parallel to Eastern Road, in about 1968 on the site of the early nineteenth-century Belle Vue Hall. This residence, the engraving of which dates from the 1830s, was once the home of William Percival Boxall, the developer of Percival and Clarendon Terraces on Marine Drive. Prior to demolition the elegant house was being used as a nursing home. The Hall's flint garden wall survives, as does the gardener's cottage. This building is now *The Coach House* (22 Walpole Road), an arts venue and community skills centre which stands behind Nos 24 and 26.

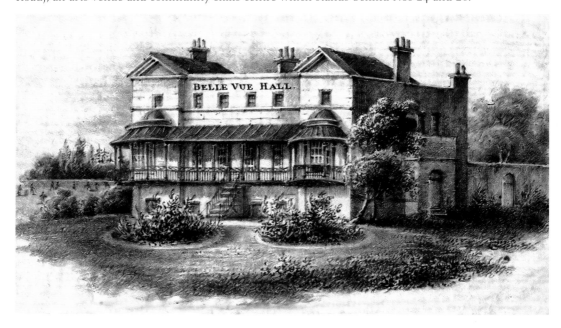

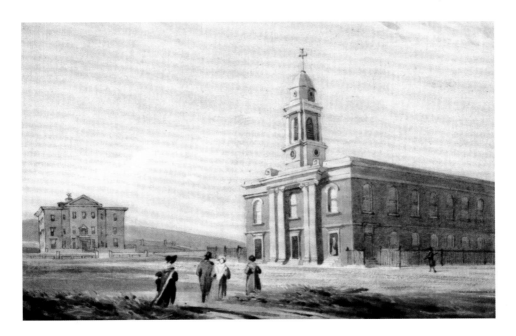

St George's Church, St George's Road

The Church of St George the Martyr was built in 1824-25 by architect Charles Busby for Thomas Read Kemp and was opened to the public on 31 December of the latter year. Considerable internal alterations were made in 1889-90. The church has in the past been under threat, actually closing for some years from about 1965, but seems secure following a merger with the parish of the former St Anne's Church, Kemp Town. The isolated county hospital building in the background above contrasts with those in the modern picture which form part of today's complex.

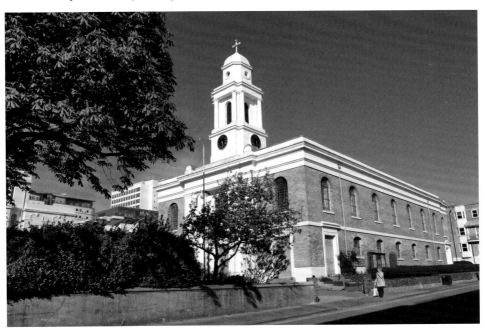

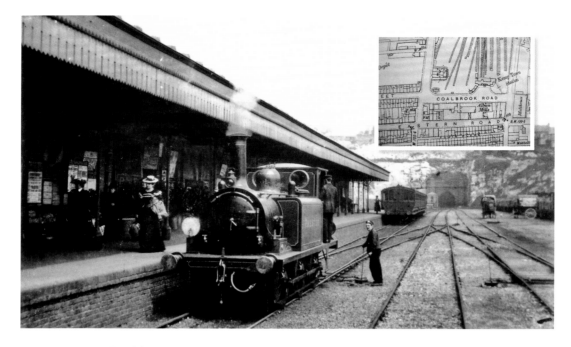

Kemp Town Station (1)

The short but expensive branch line from Brighton railway station to Kemp Town opened in August 1869. With its costly viaducts and tunnel, it never paid its way. It carried passengers until 31 December 1932 and goods until late June 1971. Above, 'Terrier' tank No 63, *Preston*, built in Brighton in 1875 and withdrawn in 1925, stands at the terminus, about to run round its train. In the background in both pictures is the portal of the branch's long, single-bore tunnel set in the chalk cliff.

Inset: Map of Kemp Town station area (OS of 1911, LXVI.6).

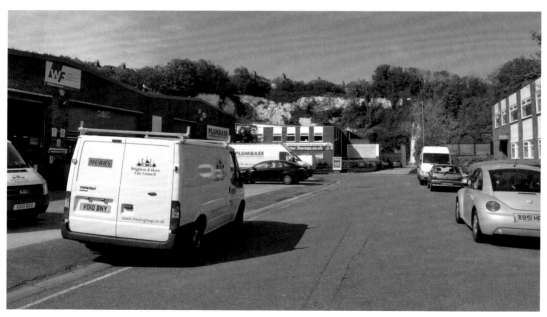

Kemp Town Station (2)

The Freshfield Industrial Estate and the car park for the Gala Bingo premises now occupy the site of the former railway terminus. The station, seen here on 18 October 1964, stood in Coalbrook Road, now no more (see map). The building was similar in design to those at Portslade and London Road (Brighton). Behind it were an extensive coal and goods yard and a long single platform.

Inset: The commemorative loco which stands near the site of the station is not only in disgraceful condition but mechanically nonsensical.

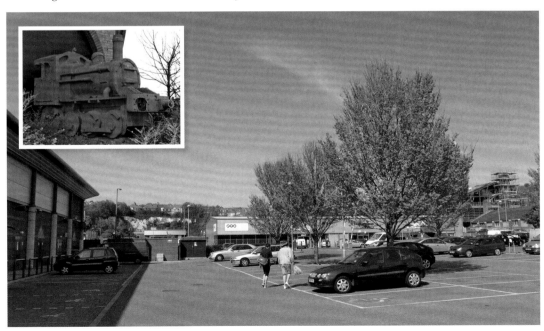

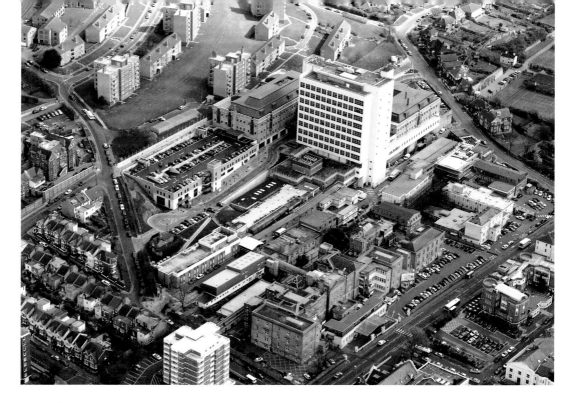

The County Hospital

By good fortune, two detailed aerial shots of the Royal Sussex County Hospital and environs from roughly the same height and angle have been located. Dominating the modern view, with the Bristol Estate on its left, is the Tower Block in Bristol Gate, opened in 1969-70. Charles Barry designed the main building in the foreground (see page 17), which opened in 1828 and is named after him. The adjacent Jubilee Building was added in 1887 and the Millennium Wing in 2000. Royal status was conferred in 1911.

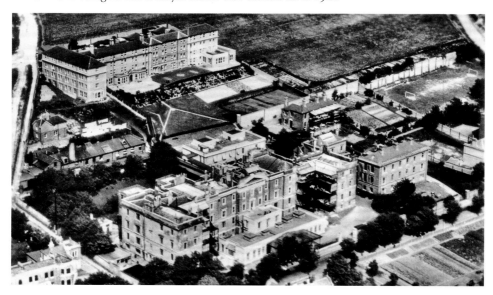

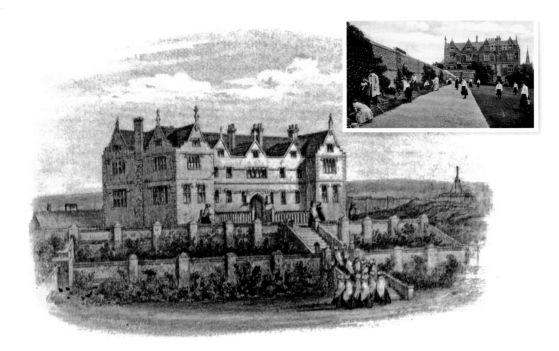

St Mary's Hall

St Mary's Hall, erected on nine acres of land given by the Marquess of Bristol, was founded in 1836 by the Revd Henry Venn Elliott, curate of St Mary's Church (see p. 13), as a school for the daughters of clergymen. Its relative isolation in around 1860 is apparent in the above engraving by Norman & Co of London. The establishment, whose attractive south façade is today enhanced by a spreading pine tree, became part of Roedean School in April 2009 following a merger. Roedean Junior School is now situated on some of the site.

Inset: Pupils gardening in the early 1900s, with the west elevation in the background.

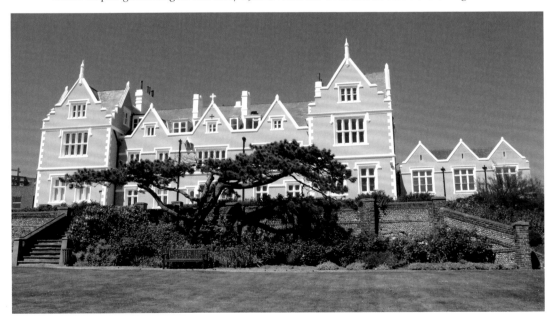

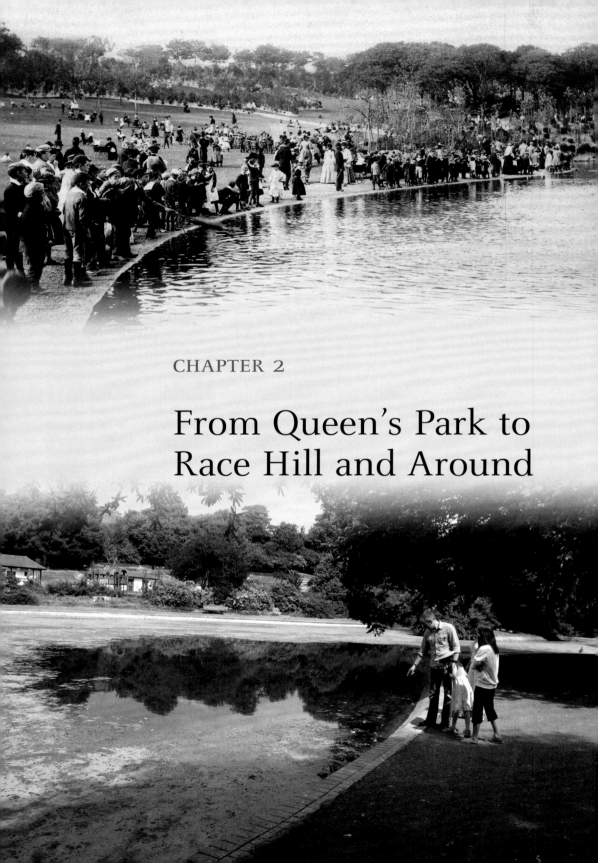

CHAPTER 2

From Queen's Park to Race Hill and Around

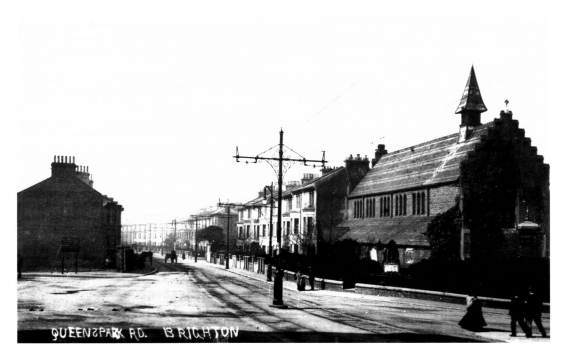

Queen's Park Road

Trams ran along this thoroughfare – seen above in around 1910 – from 1902. On the right stands the red brick hall of nearby St Luke's Church. Constructed in 1875, the hall was used until 1885 as a temporary church and mission to St Mary's. On a map of 1897 it is designated a Sunday School. Damaged by fire in 1972, it was replaced four years later by Sidney Tidy House, a small sheltered housing scheme of Kemp Town Housing Association Ltd.

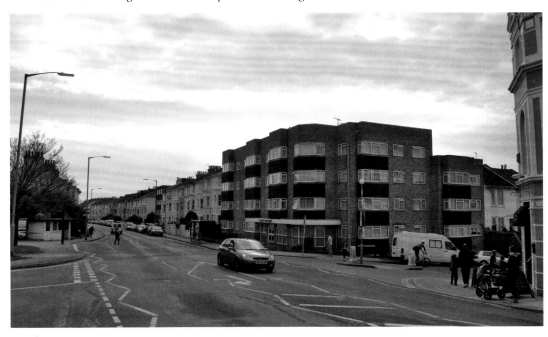

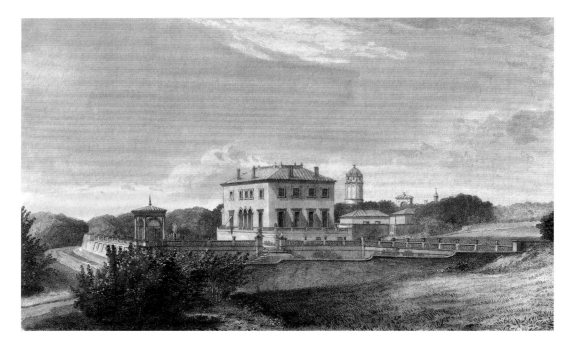

Attree Villa (1830-1972)

Thomas Attree, a prosperous local solicitor who was Clerk to the Brighton Commissioners (1810-1823) and the Brighton Vestry (1810-1830), laid out Brighton Park (now Queen's Park) in 1824, intending to surround it with private villas. Only two were actually built. This one, for his own residence, was the work of Sir Charles Barry. The Villa and its outbuildings served from 1909-66 as the Xaverian College for boys, where this author was a pupil. Only the very top of the 'Pepperpot', built as a water tower, is discernible in the lower image, captured on 30 April 2010 from Barry Walk.

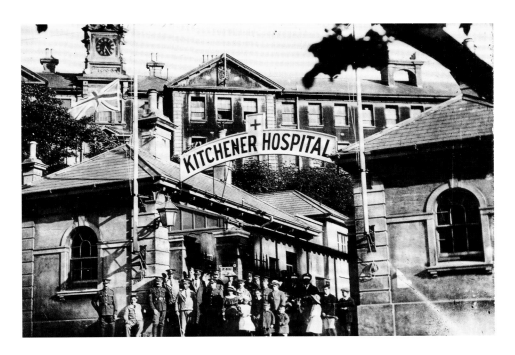

Brighton General Hospital

This was built as a workhouse in 1865-67 to the design of George Maynard with capacity to accommodate 861 inmates. Its name was changed in 1914 to the Brighton Poor Law Institution and it became a military hospital when war broke out. The 'Kitchener Hospital' opened in January 1915 and was used until April 1916 for wounded Indian soldiers and then for British troops. It reopened as the Poor Law Institution in July 1920 but in 1935 was renamed the Brighton Municipal Hospital. Its present name was adopted in 1948, the year the NHS was founded.

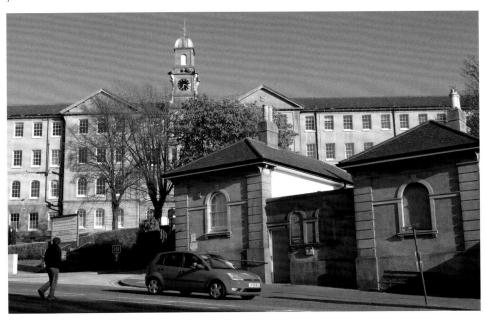

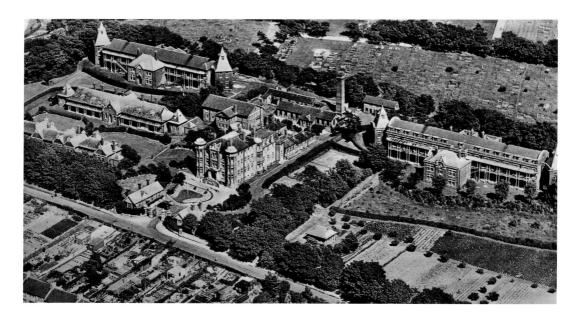

Bevendean Hospital

This institution off Bevendean Road originally opened in 1881 as a smallpox sanatorium. Not until 1898 were the main buildings erected, the complex becoming the Brighton Borough Hospital. Specialising in the treatment of tuberculosis and other infectious diseases, it was taken over by the NHS in 1948 and became Bevendean Hospital. It continued to treat patients until April 1989. Following closure, most of the buildings were demolished and a housing estate and the Sussex Beacon hospice have been built on much of the site.

Race Hill Windmill

Butcher's Mill was a white post mill of about 1823 located on ground in today's Toronto Terrace. It took its name from the first miller (other names were Park Mill and Albion Mill). It was moved to the Race Hill in late 1861. Tragedy struck in 1872 when the sweeps of the unfenced mill struck and killed George Thomas Hawes, the two-year-old son of employee Amos Hawes. In 1908, a severe gale blew off part of the body of the structure, by then in dilapidated condition, and it suddenly collapsed on the morning of 16 May 1913, an event witnessed by Walter A. Chapman of Race Hill Farm Cottage (see page 29). Today the site, leased from the Council, is home to the Southdown Riding School & Livery run by Roger Rowell and his partner Lisa Long. The mast is for emergency services communication.

Inset: The position of the mill is shown at the far right in this rare view in a postcard posted in March 1905.

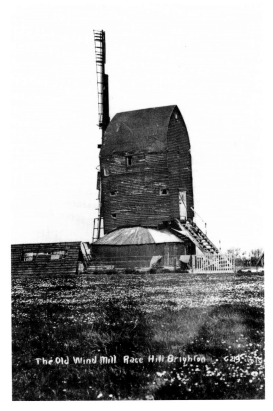

The Old Wind Mill Race Hill Brighton. 629.

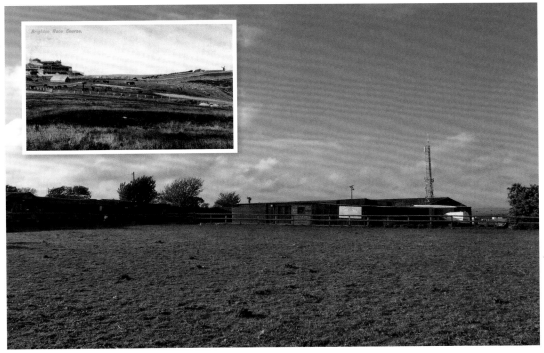

Brighton Race Course.

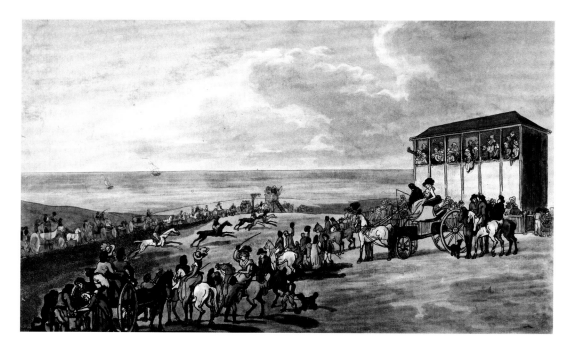

At the Races

The Race Ground by Thomas Rowlandson was etched and aquatinted by Samuel Alken in 1790 for *The Excursion to Brighthelmstone*, in which the stand is described as 'handsome and convenient' and 'sufficiently capacious to receive a great Number of Spectators'. It burned down six years later. The first known race in Brighton – a four-mile gallop over the Downs for a ten guineas prize – had taken place in August 1770 between Dr Kipping, the local surgeon, and Mr Shergold of the Castle Inn. Not until 1783 were the first 'proper' races (as listed in the Racing Calendar) held.

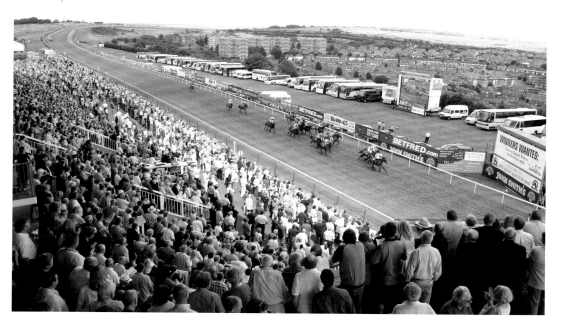

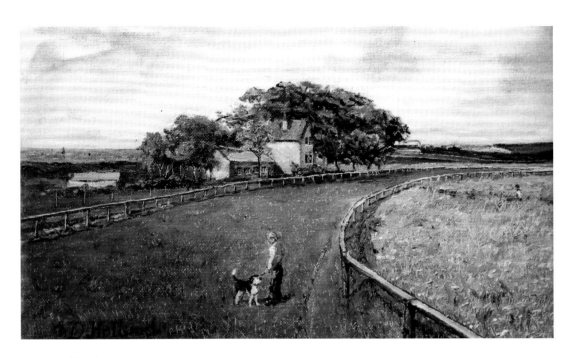

Beside the Course

This bend in the racecourse in this vivid painting by Douglas Holland (1919-2006) was a puzzle – until an old map revealed a loop at this point. The buildings shown are the farmhouse and outbuildings of Race Hill Farm. The house, demolished in the 1950s, dated from 1858 and from it two generations of the Chapman family farmed the land on which the Whitehawk estate was built in the 1930s. On Monday 10 May 2010 the VE Day Celebration Handicap was won by *King Olav*, ridden by S. Sanders.

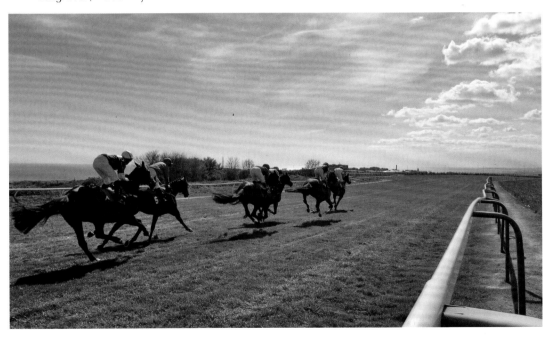

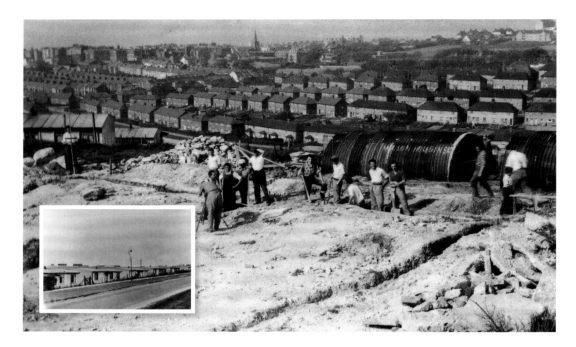

On Wilson Avenue

Wilson Avenue is a long continuous hill between Roedean Road in the south and Warren Road in the north, cutting across the Racecourse. On 9 May 1959, a skilled team of self-build tradesmen is at work on the footings of No 97, just one of the many properties constructed by the Wilson Avenue Housing Association Ltd. Behind the site, looking south-west, are houses on the Whitehawk Estate and on the left a couple of 'prefabs' (a line of which – all to be replaced by the new bungalows – is shown in the inset photograph). In the lower picture is 97 Wilson Avenue today.

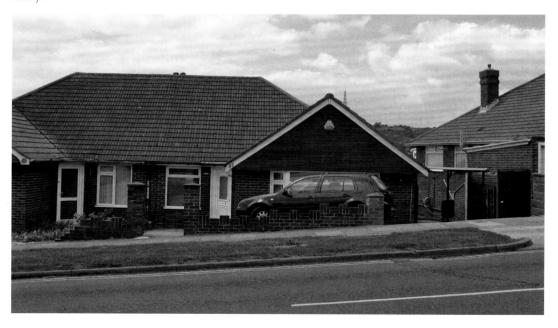

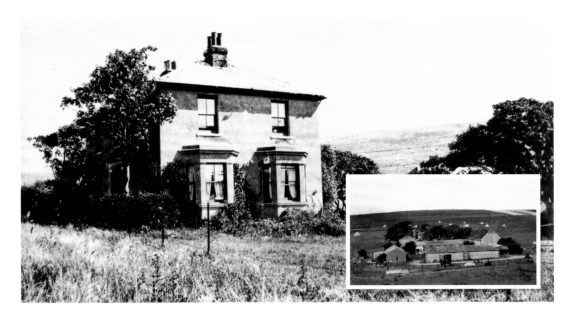

New House/Newhouse Farm

New House Farm (its farmhouse is above) was established as Rifle Butt Farm in about 1863 on land leased by Charles Beard (a major landowner in Ovingdean) to William Holford, whose son Silas inherited the lease in 1895. Silas Holford worked it until 1938 when, Brighton Council having acquired the lease, a holiday campsite was opened - the first municipal one in the country – and the farmhouse became a warden's residence. This was demolished in early 1993, while the flint barn and stables continued to serve as a hall and toilet block respectively for some years thereafter. The farmhouse of Race Hill Farm (see page 29) is visible at top right in the postcard view below which looks north-west.

Inset: Newhouse farmhouse (hidden in the background) and outbuildings, late 1930s, looking west.

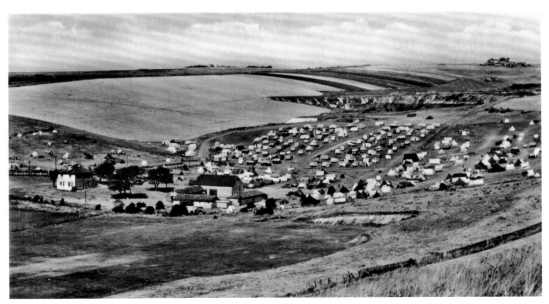

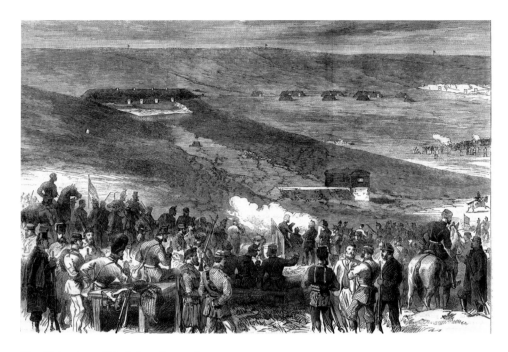

The Volunteers' Training Ground

During the 1860s in particular, a variety of military manoeuvres (including mock battles) and target practice exercises took place on the outskirts of Brighton. Here, at the Sheepcote Valley range on 31 March 1866, 750 local rifle and artillery volunteer contestants are shooting for three Enfield and three artillery carbine prizes. More than a dozen targets could be used simultaneously. The recent image shows the football pitch of Whitehawk FC and was photographed looking north-west yet still shows the extent of the former range.

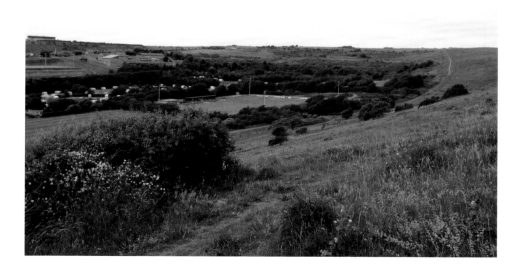

CHAPTER 3

The Estates

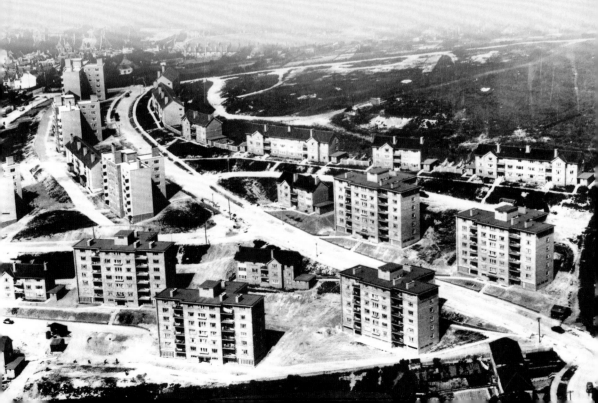

Manor Farm and Manor House

On the previous page, the upper photograph shows new houses in Whitehawk Crescent in the 1930s while the lower image also shows new properties in the form of blocks on the Bristol Estate, which celebrated its 50th anniversary in 2007. East of that estate is the Manor Farm Estate, first developed in the 1930s, which acquired its name from Manor Farm and Manor House. These were built in 1850-55 by William Hallett – see page 9 – on land purchased from the Marquess of Bristol. The house was demolished in the 1970s.

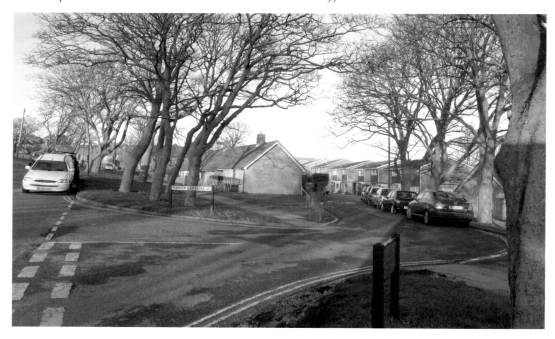

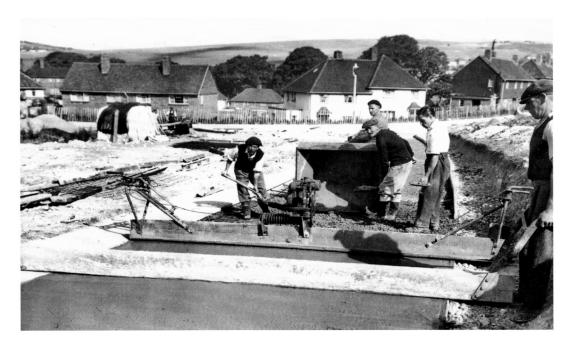

Bevendean

The farmland and open downland on which the Lower and Upper Bevendean estates would stand was formerly part of Falmer parish, itself taken over by the County Borough of Brighton in 1928. Work on the Lower Bevendean Estate began in the early 1930s. Bevendean's development continued after the war (the above photograph depicts roadworks at The Hyde, Lower Bevendean Estate's industrial area, in September 1953) and continued right up until 1970-74 (Dartmouth Close and Crescent; Fitch Drive). The 2010 photograph below shows the estate's attractive downland setting.

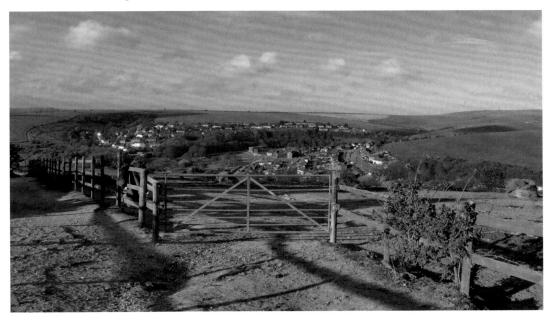

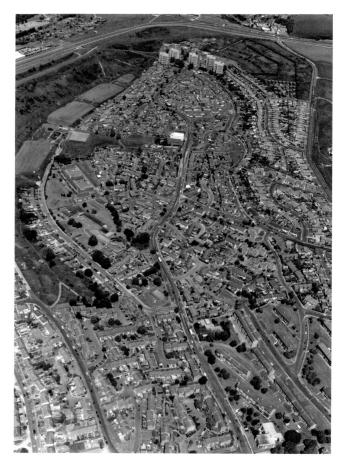

Whitehawk Panoramas

This impressive aerial view from the south-east shows the dramatic change in housing and layout following the remodelling undertaken from 1976 and contrasts starkly with the 1930s panorama below photographed from the west above Brighton General Hospital. In the latter view, Lintott Avenue – now no more – bisects the estate, on which the initial major work was undertaken from 1933 to 1937, with close on 1,200 houses being built, all with large gardens. The remodelling allowed additional properties to be constructed, giving a final total of 1,440 houses.

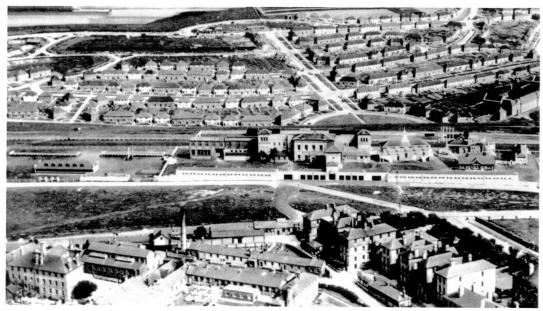

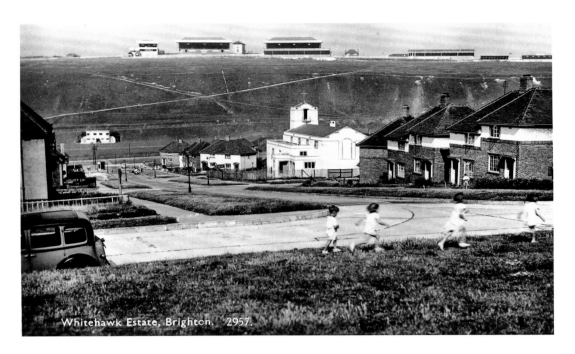

Whitehawk Estate, Brighton. 2957.

Change All Around

Nothing in the above picture, looking west from Wiston Avenue down Lintott Avenue, survives in the one below, save for the racecourse buildings – and even they have been remodelled. A new park has been laid over the avenue, whose redevelopment (south section) was completed in 1988. Whitehawk's original church, St. Cuthman's, was built in 1937 but regrettably destroyed on 16 August 1943 by a German bomb with the loss of one life. The new church was built in 1951-52. Its hall was sold to the Community Association in 1982 and became the Valley Social Centre.

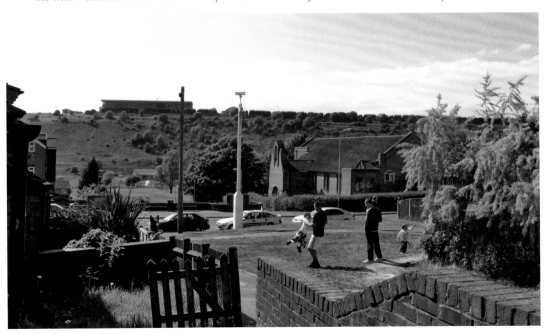

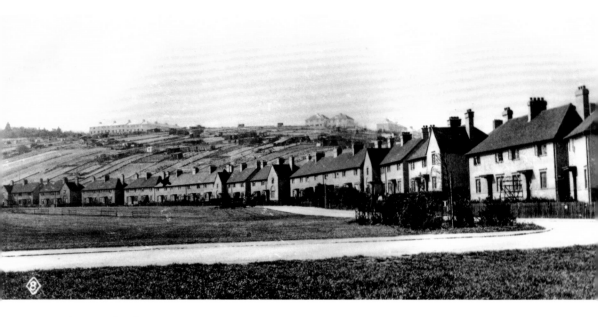

Moulsecoomb, The Avenue

The large Moulsecoomb estate developed over an extended period and comprises North Moulsecoomb, East Moulsecoomb and (South) Moulsecoomb. The latter – containing The Avenue, which extends into Bevendean – was developed first, the Borough Council having acquired land in November 1920 on which it constructed 478 semi-detached houses with large gardens and three bedrooms each but they were generally too expensive for the families they were aimed at. The North Moulsecoomb area was developed from 1926-30 onwards on 46 acres acquired in October 1925, while East Moulsecoomb began to be built by the Corporation on part of a 300-acre estate purchased in December 1935.

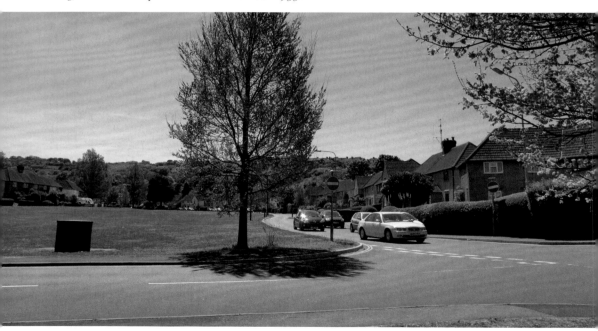

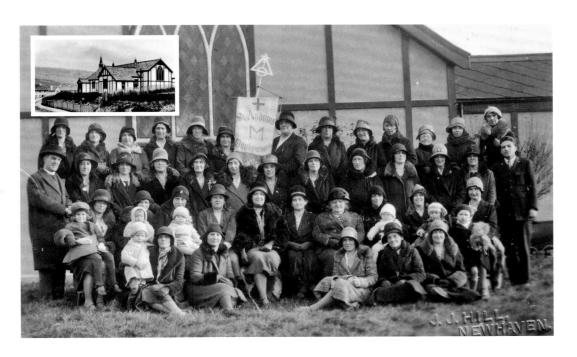

Moulsecoomb's Church of St Andrew

The occasion for this splendid gathering in, apparently, the 1920s, is unfortunately unknown. The second estate church of St Andrew, Hillside, South Moulsecoomb, was consecrated on 23 June 1934 and replaced the earlier temporary church (see above and inset) which had been removed from Lewes in 1922. This building (see above and inset) lost its spire and became a parish hall. Below, three parishioners of long standing – David and Joan Burchell and Ray Jewel – are leaving the church after Sunday service on 7 March 2010.

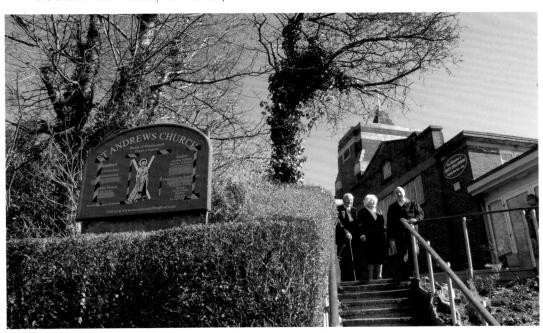

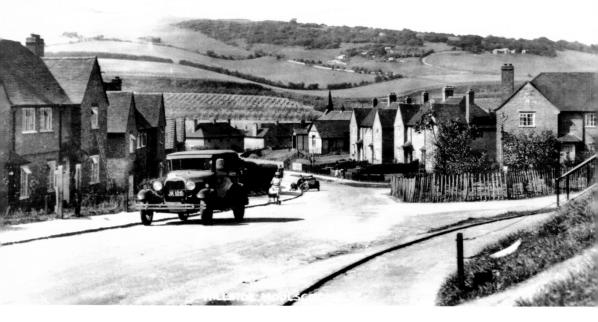

Moulsecoomb: Hillside

The spire of the first church of St Andrew can be discerned in the middle distance in this early view of Hillside, part of the 1920-24 development of the estate. Ruby Dunn wrote in *Moulsecoomb Days* (1990) 'the first attempts at community life were centred around a wooden hut with a tin roof, in Hillside, which served as Church, Village Hall and Sunday School. First Mr Hurd, then the Revd Carpenter, were in charge of our welfare.' An illustrious resident was the prolific classical composer (William) Havergal Brian (1876-1972), who lived at No 130.

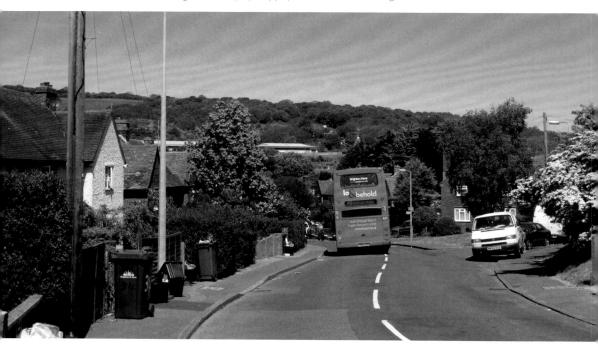

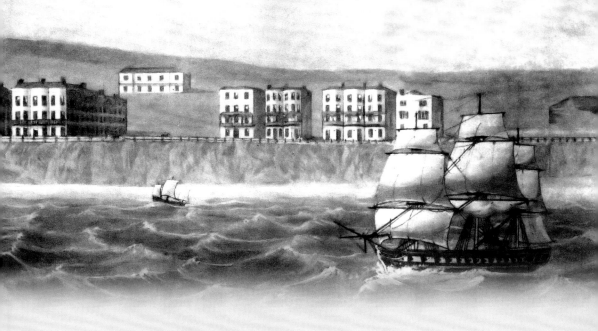

CHAPTER 4

Black Rock
and the Marina

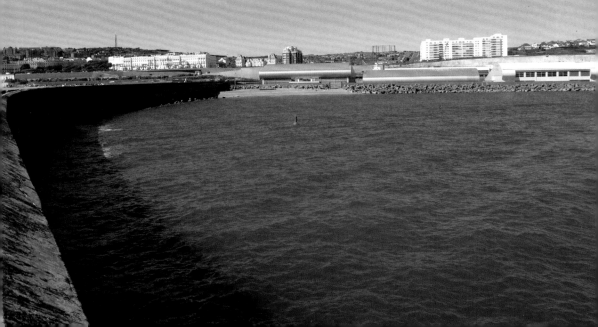

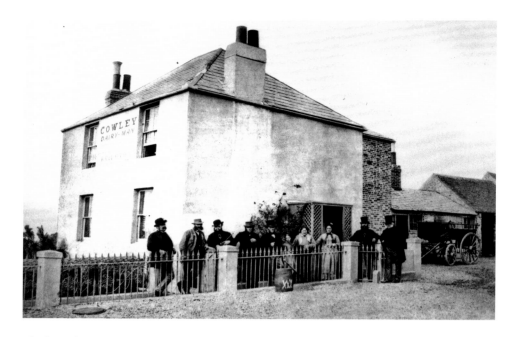

Black Rock Farm and the Cowleys

The panorama print by Robert Havell Jr which is shown in part on the previous page was published in London in 1824 and is thought to be the only early image to depict the gasworks established in 1818/19 at Black Rock. The contrasting view was taken from the west arm of Brighton Marina. The Cowley family, captured here in a splendid family photograph taken in the 1860s, successfully farmed Black Rock Farm between 1839 or earlier and 1899. The severe landslip of January 1891 at this unstable location endangered the farm buildings and the adjacent coastguard station, resulting in the eventual abandonment of the former and the relocation of the latter.

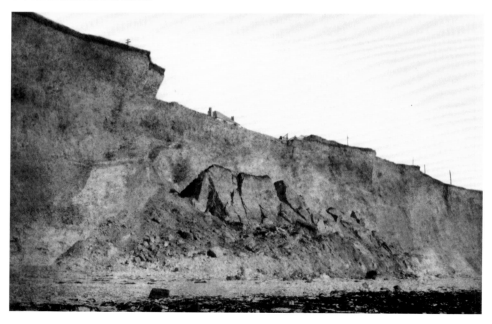

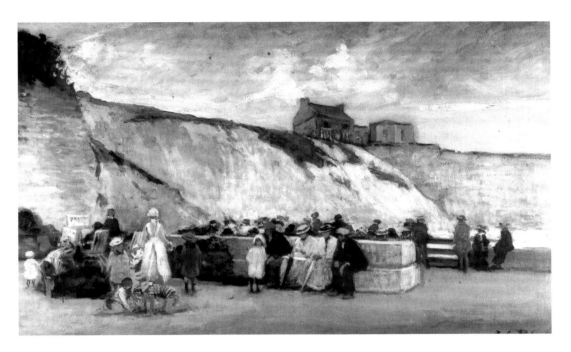

Black Rock Cliffs in Art and Photography

This Impressionist-style painting by French artist Jacques-Emile Blanche (1861-1942) is surprisingly entitled 'Black Rock, Brighton, 1938'. Most of the work on it had in fact been done earlier, possibly around 1922, the year after the square terrace garden had been laid out, its 'seats' being formed from the large white blocks of stone used for building the sea wall. On the top of the cliffs are Black Rock House, the Abergavenny Arms and the Cliff Creamery – all of them gone by the alleged date of the painting! The sepia view below is on a postcard posted in March 1911.

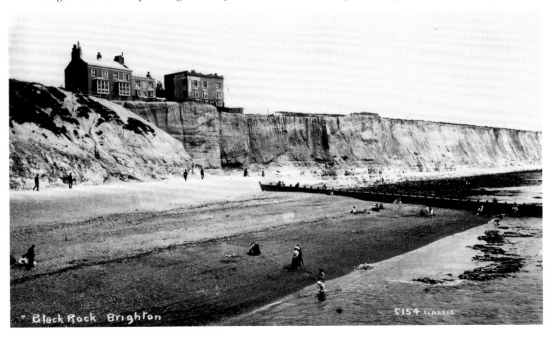

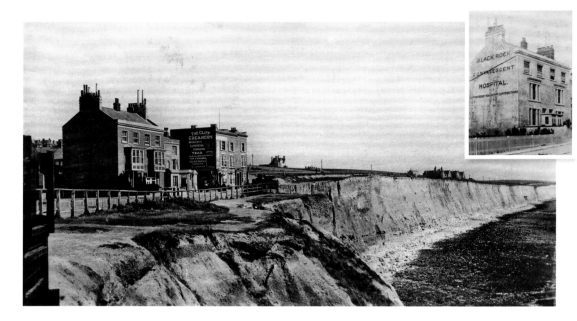

A Radical Change of Scene

A postcard sent in July 1908 provides a very clear view of the three buildings on Sea View Terrace. By 1929, the houses were perilously near the cliff edge. Black Rock House (left) was demolished in that year and the Cliff Creamery (right) soon followed. The Abergavenny Arms in between them lasted until 1932 when it was swept away in connection with work on the new coast road. The 1960s coloured postcard below depicts the Marine Gate flats and the Undercliff Walk. Both cards show White Lodge – see page 62 – in the middle distance and Roedean School in the far background.

Inset: Black Rock House served as a convalescent hospital from around 1890 to the early 1900s. Photograph by A. E. Slater of St George's Road.

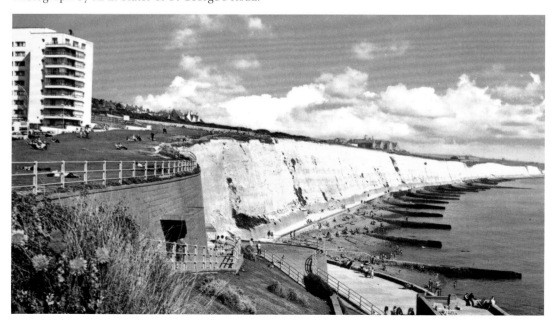

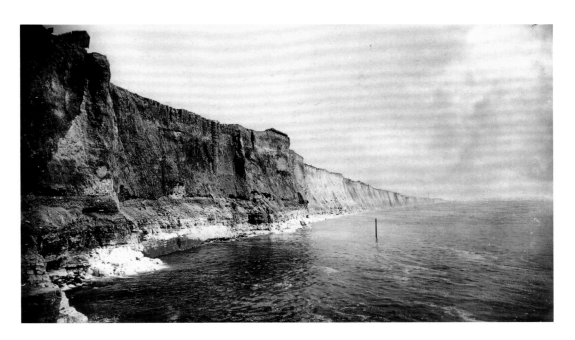

An Unstable Location

The protruding formations of chalk in the above view appear very prone to collapse. Instability remains a problem: on 9 April 2001, more than twenty shoppers and seventy-five members of staff were hurriedly evacuated from the Asda store (right) at the Marina. Rocks and debris crashed into, and disabled, the water tank and an electricity generator. In early February 2010, falling chalk caused the route of the 20th Sussex Beacon Half Marathon to be altered. At the time of writing, 1 km of the Undercliff Walk remains closed.

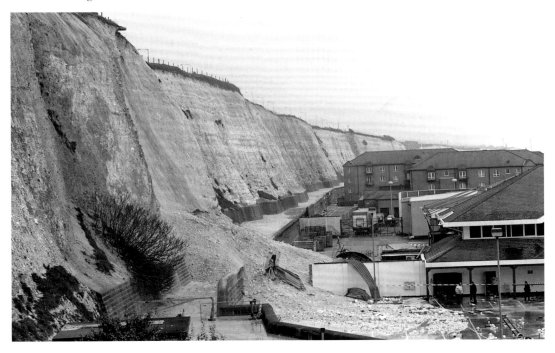

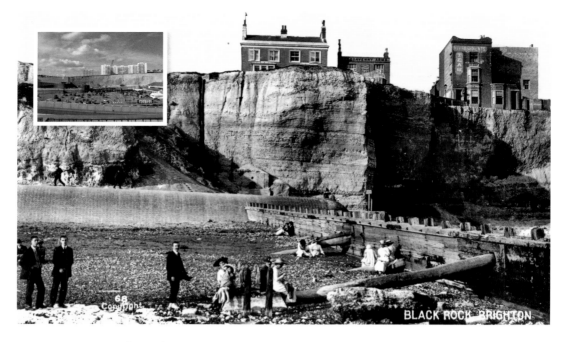

BLACK ROCK, BRIGHTON

An Area Transformed

The above view allows the clifftop buildings to be seen in detail. Careful examination of the gulley on the left reveals steps cut into the steep pathway. Black Rock swimming pool was built a few hundred yards to the left. Occupying the site of the terrace garden we saw earlier and beyond, it opened on 8 August 1936 and was well patronised for many years. Severe structural problems and the rise in popularity of foreign holidays forced its closure in 1978. The construction work on Marine Gate in the background dates the photograph to 1937-9.

Inset: The cliffs and Marine Gate from the roof of the Marina car park in May 2010.

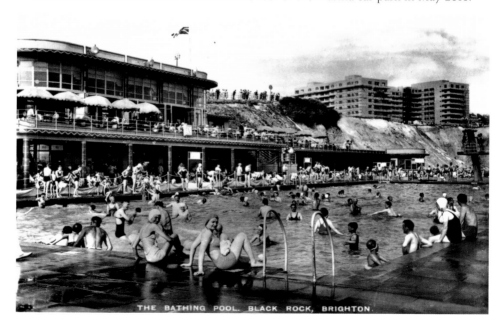

THE BATHING POOL, BLACK ROCK, BRIGHTON.

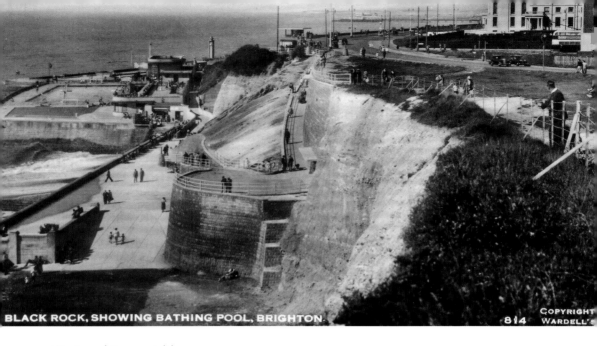

BLACK ROCK, SHOWING BATHING POOL, BRIGHTON. 814 COPYRIGHT WARDELL'S

Westward Prospect (1)

The exact site of the pool is clear from this late 1930s postcard by Wardell. Access to the undercliff area is now easy and the new coast road is carrying the light traffic of the day. The postcard below was written on 20 July 1930 – exactly eighty years prior to this caption being penned. The Bungalow Station of Volk's Railway seen here was later sacrificed for the new pool, as was the site of the old builders' yard adjacent to it. On the clifftop, the Cliff Creamery precariously survives.

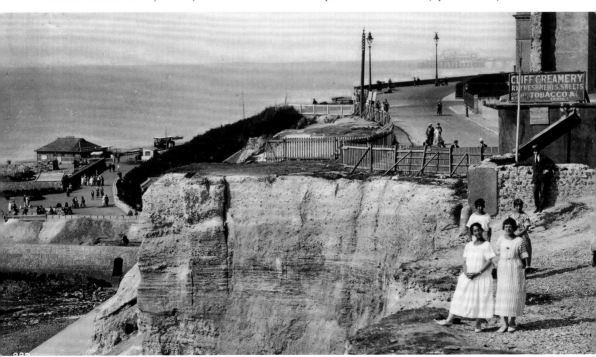

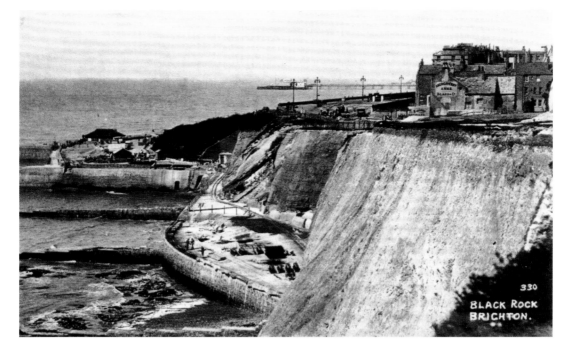

BLACK ROCK
BRIGHTON.

330

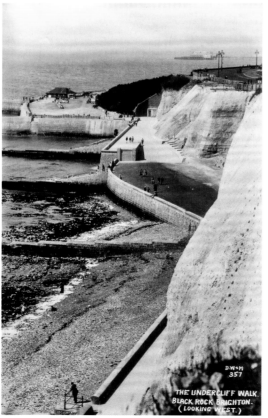

THE UNDERCLIFF WALK.
BLACK ROCK BRIGHTON.
(LOOKING WEST.)

D.W+M
357

Westward Prospect (2)

The builders' yard has been cleared and work is proceeding on the construction of the Undercliff Walk to Saltdean. Near the coast road, the Abergavenny Arms stands as the last survivor of the three clifftop buildings. The picture can therefore be dated to perhaps late 1932. The postcard left was sent two years later and shows the Walk at this section now complete.

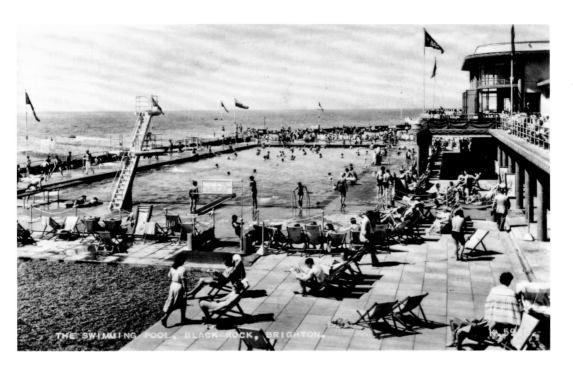

From a Summer Paradise to Desolation

No greater or more deplorable contrast is imaginable than these two views, one from August 1957 (posting date) and the other from June 2010. The pool and its buildings stood derelict until 1984. Various development schemes proposed since then have included a water park; a hotel with spa and winter gardens; and a multipurpose arena including two ice rinks plus 109 residential apartments. The latter scheme, from Brighton International Arena, won Council acceptance but has been shelved due to economic conditions – and the blot on the landscape remains.

Inset: Graffiti at Black Rock.

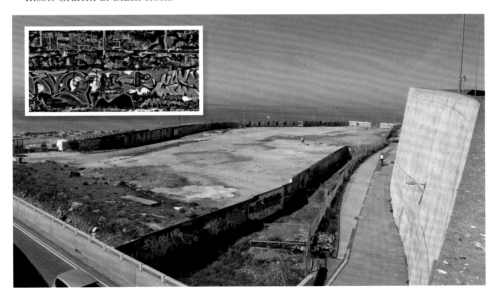

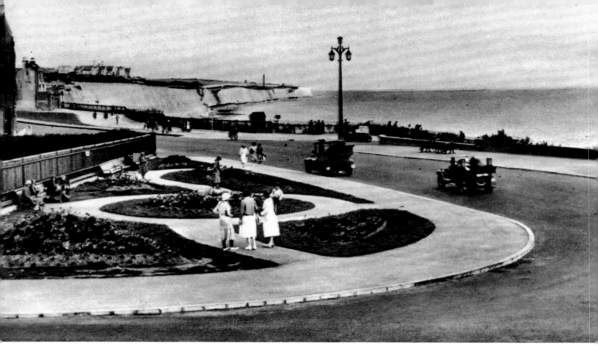

The New Rottingdean Road
This postcard showing the junction between Arundel Road and Marine Parade can be dated to 1932/33 since the new coast road to Rottingdean was opened in the former year (see also page 63) and the distant sewage ventilation shaft chimney was demolished in the latter. Prior to the completion of this highway, Roedean Road had been used since 1897 as an alternative to the clifftop road which had become unusable east of Black Rock owing to cliff erosion.

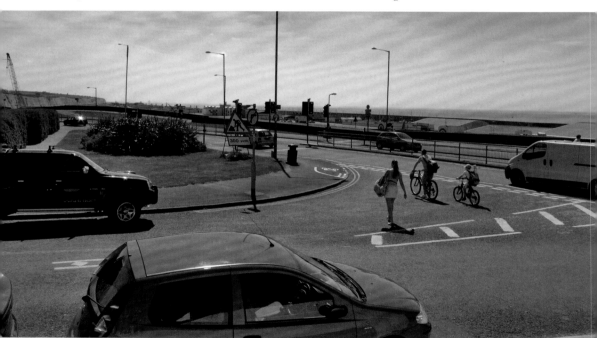

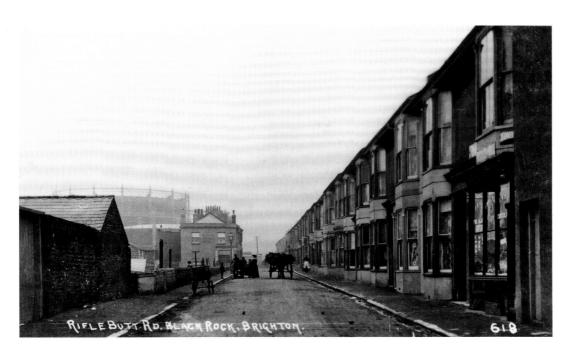

Rifle Butt Road (1) looking North

This road of terraced houses, a few businesses, a place of worship (the Friends Meeting House of 1856) and even a small burial ground, lost a number of properties at its southern end through work on the new coast road. The old Abergavenny Arms was swept away at the same time, as were twenty tiny houses nearby named Black Rock Cottages. Rifle Butt Road was lost altogether when it was demolished for the building of the Marina road interchange which opened in 1976.

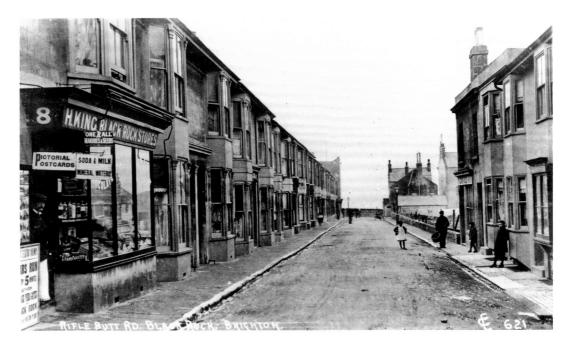

Rifle Butt Road (2) looking South

Rifle Butt Road acquired its name from nearby Sheepcote Valley being a training area for volunteer soldiers, complete with targets (see page 32). At the door of the Black Rock Stores, left, Mr H. King makes a low-key appearance. The board proclaims that 'Cars run every 5 minutes between the Palace Pier Gates and Black Rock'. At the end of the row on the right where the wall begins is the Black Rock Bakery (see also previous page), established in 1856 and demolished in 1972.

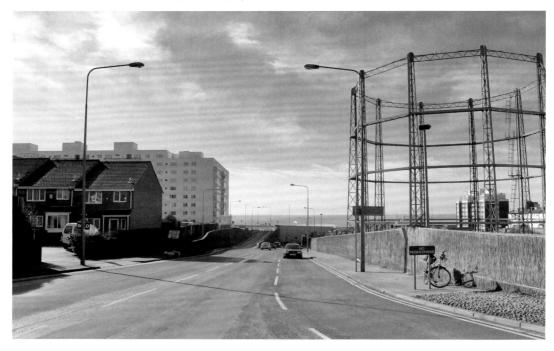

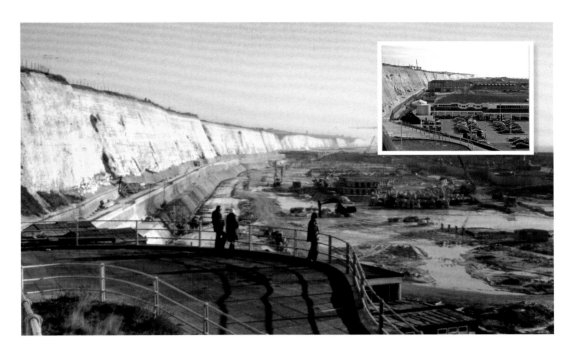

The Marina: Emptying and Re-filling the Basin

Work on the £41 million Brighton Marina scheme started in January 1971. Once the site had been enclosed and drained, key construction operations could be got under way. Below is the complex in its early (pre-1982) form, with pontoons still being positioned. Dominating the scene is the MV *Medina III* (built 1931, withdrawn 1962), formerly on the Isle of Wight run. The first diesel ferry of the Red Funnel company, she was used at the Marina as a floating restaurant (*The Captain's Table*) and as the first premises of Brighton Marina Yacht Club, formed in 1978.

Inset: The western end of the Marina, February 2010, showing the Asda store and car park.

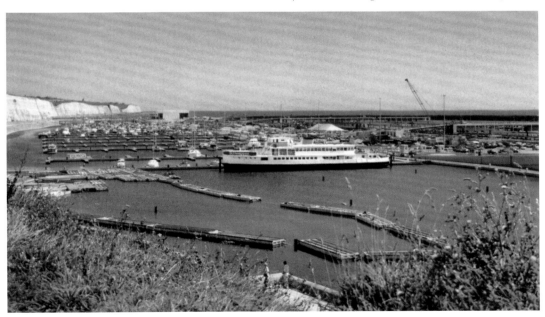

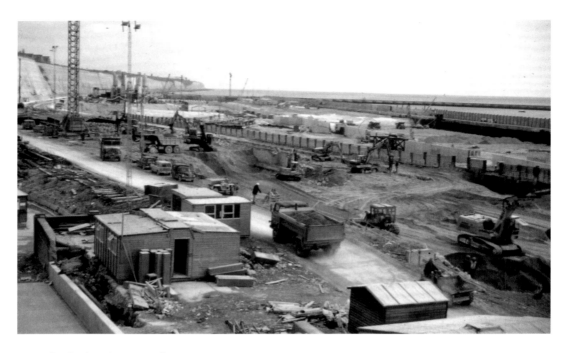

From Seabed to Supermarket

Work on the reclaimed land continues apace in this scene of bustling activity. The retaining wall to hold back the sea was made of steel piles clad with reinforced concrete. Despite attacks by the sea, it was completed by June 1971. In the distance, the eastern arm curves away from the line of cliffs. Today, Asda's car park dominates the scene. On the right are the access ramp from/to the coast road and the multi-storey car park.

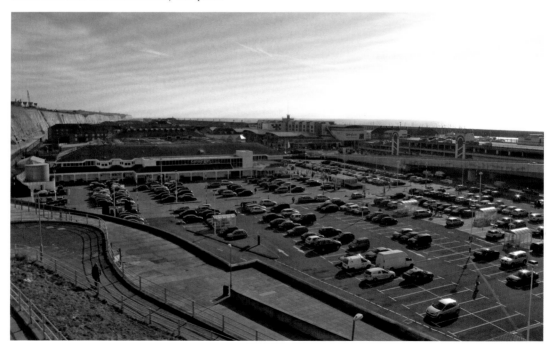

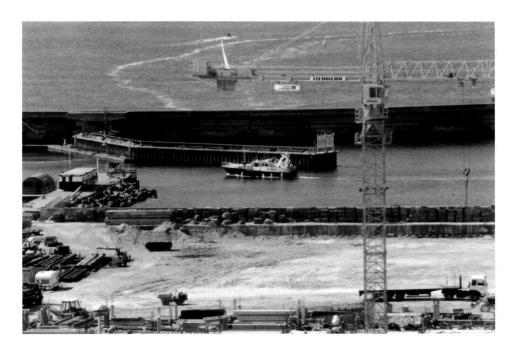

Looking South (1)

The land is here being cleared near the harbour's inner entrance, facing the south quay and eastern breakwater. On the left is the west quay and the RNLI station site, which is fully developed in the lower picture. Today, regular buses serve the bustling complex, there is ample multi-storey parking and, nearby, a wide and varied range of retail outlets, restaurants and bars. In other parts of 'Marina Village', numerous apartments provide desirable accommodation in a healthy and unique environment.

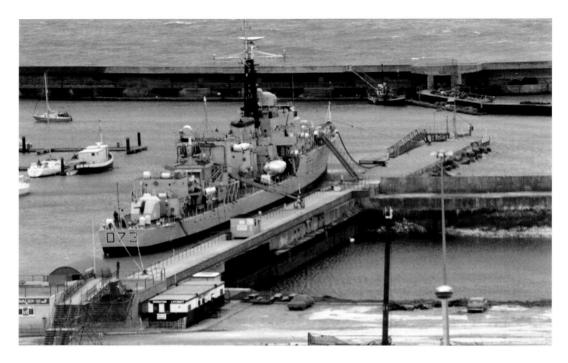

Looking South (2)

HMS *Cavalier,* seen here at the west quay, was the Royal Navy's last operational Second World War destroyer. Refitted and modernised in 1957 she continued to play an active role as part of the Royal Navy's Far East and Home fleets until she paid off at Chatham in 1972. She is now preserved there as a memorial to the 143 British destroyers and over 11,000 men lost at sea during the war.

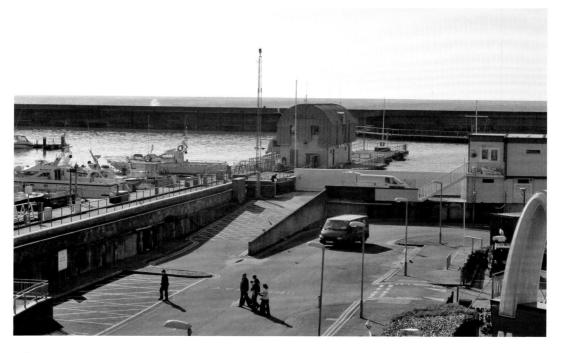

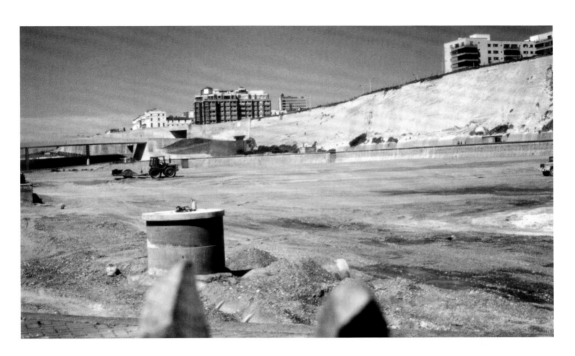

Looking West (1) – A Dry Bed Transformed

Over a period of many months dredgers worked off the Isle of Wight and conveyed their loads of marine ballast into Shoreham Harbour from where a fleet of lorries transported it via the coast road and tipped it onto the Marina site. No less than 20,000 tons a week were spread over the area and a total of 600,000 tons were needed to fill it. In the distance in both pictures is the apartment block Courcels, built on the site of nineteenth century Madeira Mansions and, on the right, Marine Gate.

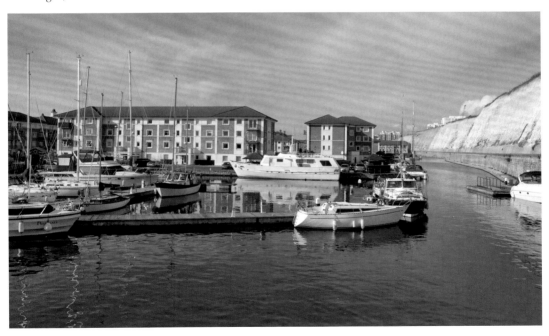

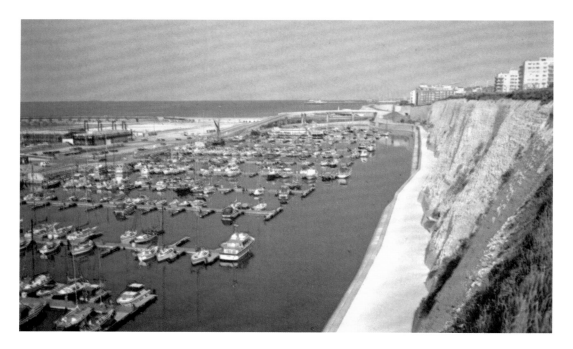

Looking West (2) – From Roedean

The original vision for the Marina was a great harbour with supporting services and a range of leisure facilities. Housing was planned initially to be sited on a central spine, called the Strand, between two basins. When the Marina was sold to leisure giants Brent Walker in November 1985 for £13 million, projected work included the building of 800 homes. The first ones were opened in 1988. Below is seen some of the extensive residential development which has materialised over the years: Trafalgar Gate (left) and Mariners Quay (facing).

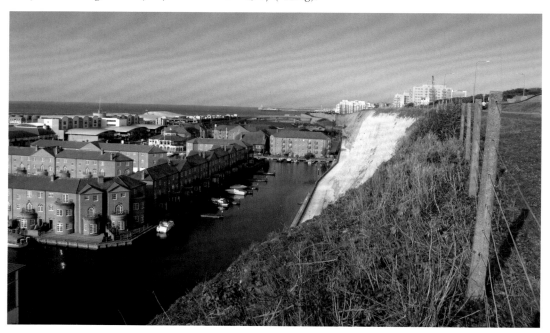

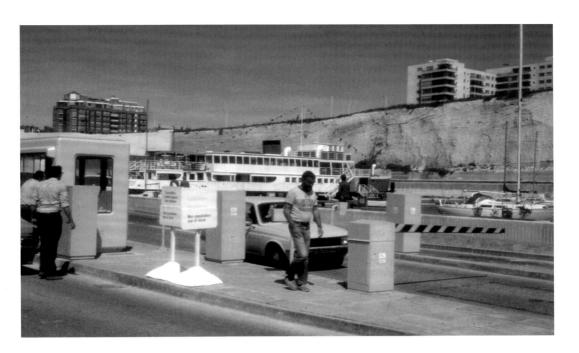

Ticket Barriers

Prior to completion of all the areas, a toll of 30p for adults and 15p for seniors and children applied to the general public for admission to the Marina. Vehicles of non-berthholders were also charged. Behind the entrance barriers above, the MV *Medina III* (see page 53) lies at her mooring. Dominating the background in the March 2010 picture is the Aqua Bar & Marina Spice restaurant in Village Square. The large barn-like building on the right is the Master Mariner pub and restaurant in the Inner Lagoon.

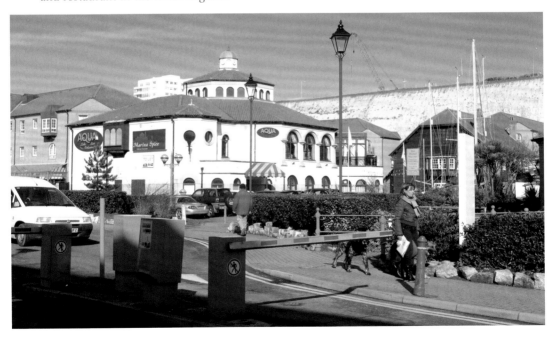

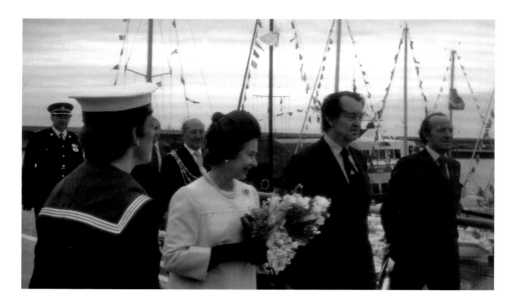

The Grand Opening

On 31 May 1979, HM the Queen opened the Marina. 'Boats were dressed overall; yards were manned; the royal standard was hoisted; and the crowds waved their greetings as the Queen passed by. A plaque was duly unveiled and the Brighton Marina was in business.' (George Horrobin). Her Majesty could never have dreamed of the vast and thriving complex that today's Marina, seen below in a fine aerial shot taken in 2006, would become.

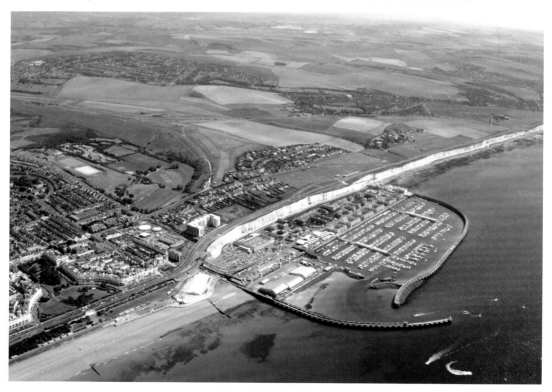

CHAPTER 5

Roedean

Early Homes

On the previous page, George Dudeney drills corn in the early 1920s on Red Hill, just north-west of Roedean, on land today occupied by East Brighton Golf Course. A contrasting picture from the east reveals the community's favoured position between the downs and the Marina. Roedean Terrace was originally made up of a row of coastguard cottages (above) put up in around 1900 to replace those at nearby Black Rock threatened by coastal erosion. *White Lodge on the Cliff* (below) was designed by the architect of Roedean School, John Simpson, and dates back to 1904. Now much altered, it was the home of Lady Victoria Sackville from 1923 to 1936.

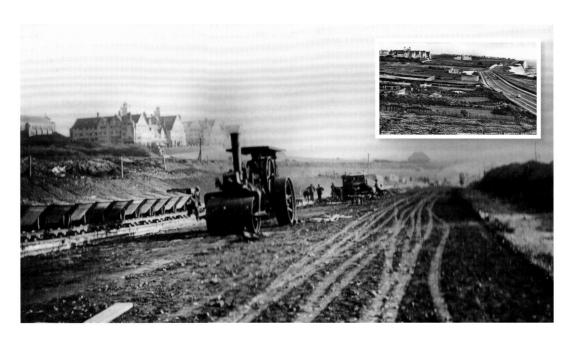

The New Road to Rottingdean

Roedean School is seen again in this 1932 view of the construction of the new 60-foot-wide Marine Drive, opened on 22 July of that year. Today (2010) work on the coast road at this point continues in a different form: a pumping station shaft 46 metres deep is being dug for the sewer running east from the Marina to the new treatment works at Lower Hoddern Farm, Peacehaven. A second shaft is being excavated in connection with the tunnel between Marine Gate Pumping Station and Portobello, Telscombe Cliffs.

Inset: This sharp post 1939 sepia postcard by A. W. Wardell shows the road in (sparse) use, with Roedean Café in the middle distance and St Dunstan's (see page 70) in the background.

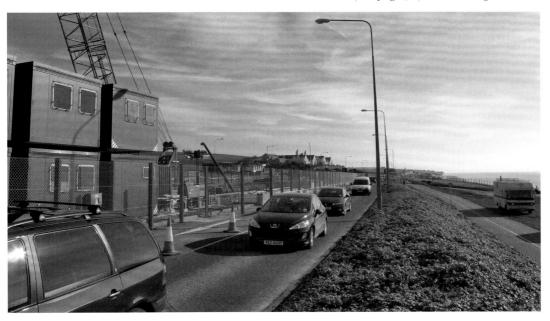

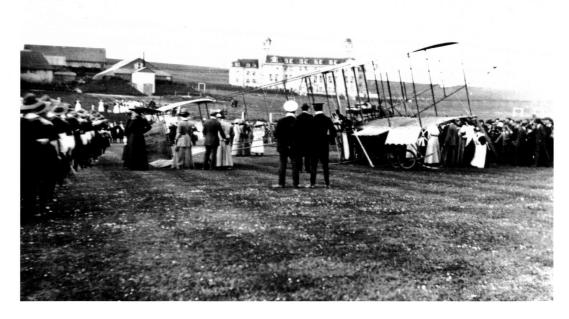

Roedean School Lawns

On 13 May 1911, Roedean School welcomed two heroes of the air, Oscar C. Morison and his rival Graham Gilmour. Both had just competed in a side-by-side race in their Bristol biplanes from Shoreham Airport to the borough boundary at Black Rock. Morison won and was presented with the first prize of £25 by Magnus Volk, who had promoted the race. Four years later, on 3 July 1915, Lt-Gen. Sir Robert Baden-Powell, in his capacity as Chief Scout, visited the School. Here 600 Guides were lined up for inspection.

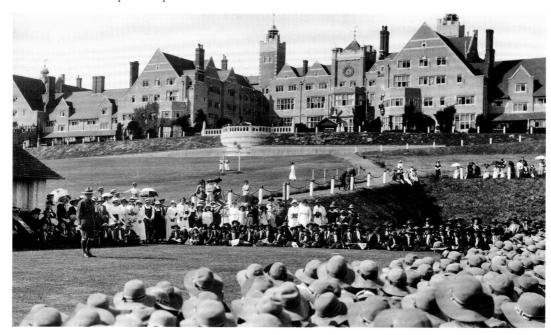

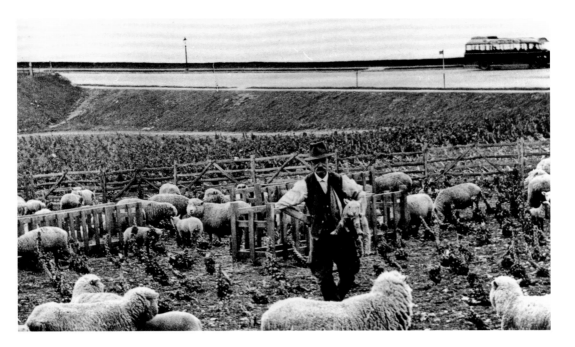

No Sheep Hereabouts Nowadays
Ben Dudeney (1874-1955), shepherd for farmer J. A. L. McCullum of Greenway Cottages, Ovingdean, with his charges west of Roedean School. A story by Rudyard Kipling, *The Knife and the Naked Chalk*, first published in 1909, featured Ben Dudeney, shepherd, who lived at Mill Cottage at the top of what later became Bazehill Road, Rottingdean. In the background is a Southdown Leyland Tiger TS7 bus, one of a batch of 24 saloons introduced in Brighton for route 12 in 1935.

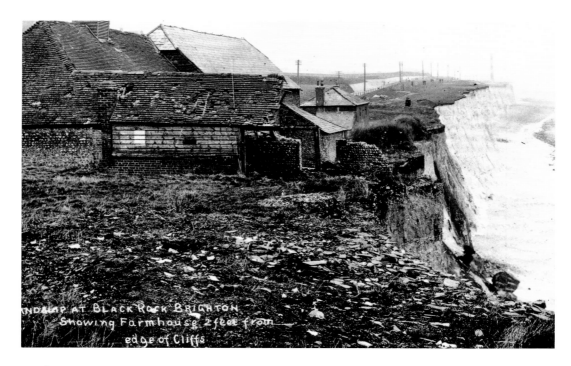

ND&LIP AT BLACK ROCK BRIGHTON
Showing Farmhouse 2 feet from
edge of Cliffs

Roedean Farm

The buildings of Roedean Farm were removed at the time Marine Drive was constructed, the open spaces along the clifftop having been acquired by Brighton Corporation in 1928-35. The caption 'at Black Rock' is confusing but the location is certainly Roedean (the school can be glimpsed at the top left of the picture behind the barn roof).

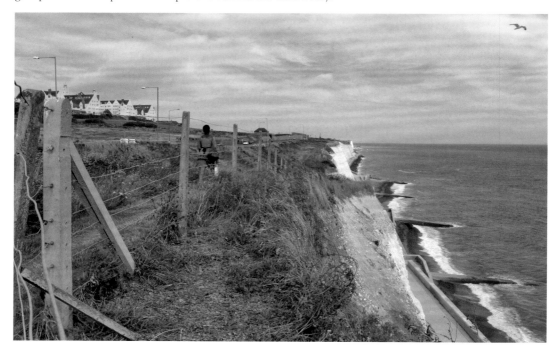

CHAPTER 6

Ovingdean

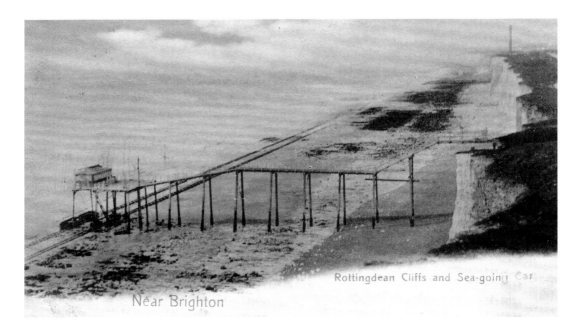

Rottingdean Cliffs and Sea-going Car

Near Brighton

A Long-lost Railway

A rare view, by Hellier's Original Exclusive Postcards of Brighton, of the jetty and sea-going car (the *Pioneer*) of Magnus Volk's Brighton and Rottingdean Seashore Electric Railway at Ovingdean Gap. The card was posted on 27 July 1907. The jetty was not dismantled until 1910, fully nine years after the service was withdrawn. The industrial silos at right in the recent view form part of the installations, at the junction of Greenways and the coast road, connected with the wastewater transfer tunnel being built between Brighton and Friar's Bay, east of Peacehaven.

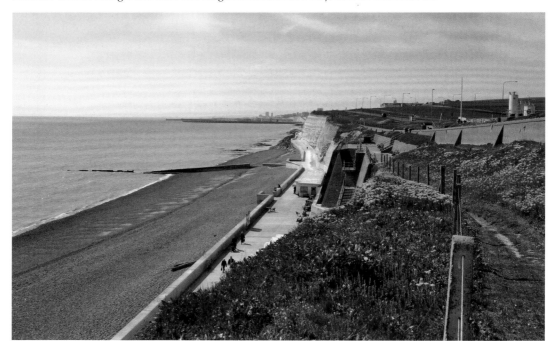

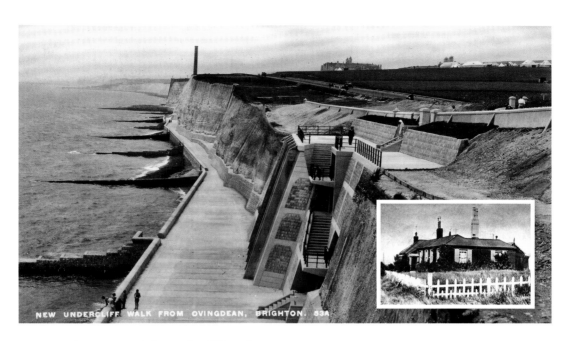

NEW UNDERCLIFF WALK FROM OVINGDEAN, BRIGHTON. 53A

Beach Access and the Undercliff Walk

This anonymously published postcard, sent from Brighton in 1933, shows the newly-constructed stone steps built as part of the new Undercliff Walk (opened from Brighton to Rottingdean on 4 July of that year) to replace the former wooden ones from the clifftop to the beach. In the distance are Roedean School and the sewage ventilation shaft chimney demolished in 1933 in connection with the widening of the coast road. Today, Ovingdean Café on the Undercliff Walk always attracts locals and visitors when the weather is favourable.

Inset: An exceedingly rare picture of Greenway House, a former coastguard building being used as a residence, which stood in this vicinity.

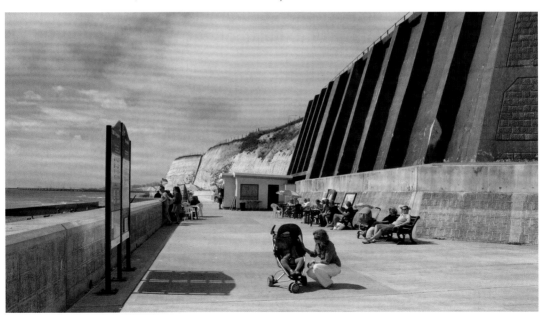

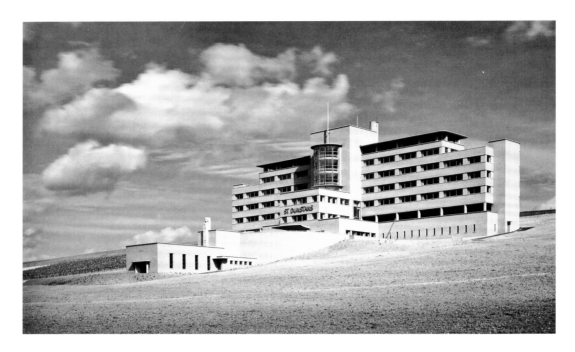

St Dunstan's

The seven-storey St Dunstan's building, designed by Francis Lorne, in Greenways near Ovingdean Gap for the rehabilitation of blind ex-Service men and women was completed in 1938 and called St Dunstan's Ovingdean. Many reconstructions and refurbishments have been made over the years. The centre now provides training, rehabilitation, holidays, residential and nursing care. One of the extensions can be clearly seen to the right of the building in this animated view of a fete held in the grounds on 12 September 2009.

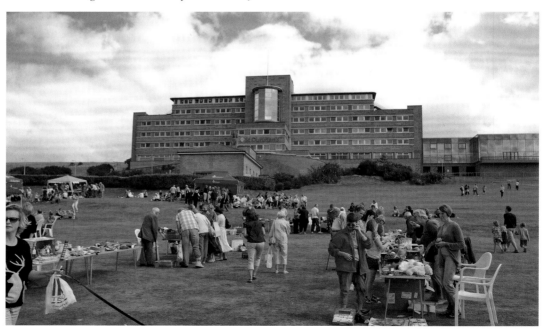

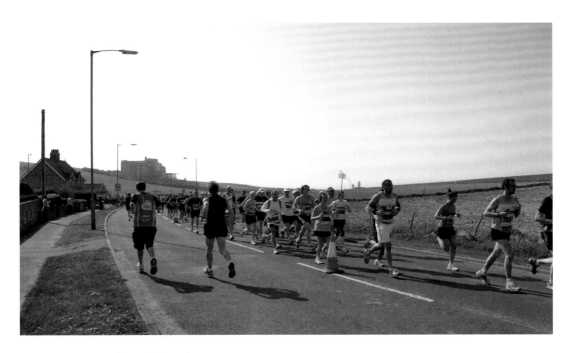

Running and Marching along Greenways

It is 18 April 2010 and the runners in the first Brighton Marathon are pounding their way along Greenways, formerly Greenway Road, the long thoroughfare from the coast to inland Ovingdean. In the lower picture, men of the Territorial Army on their two-week long camp for military training in the 1920s march past the house of William Henry Beaumont, an early builder/developer in Ovingdean (see page 73). St Dunstan's, seen above, would not be built for nearly two decades.

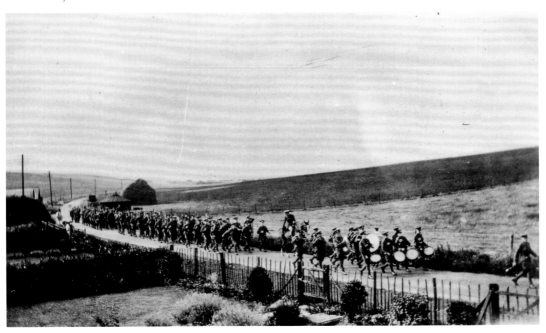

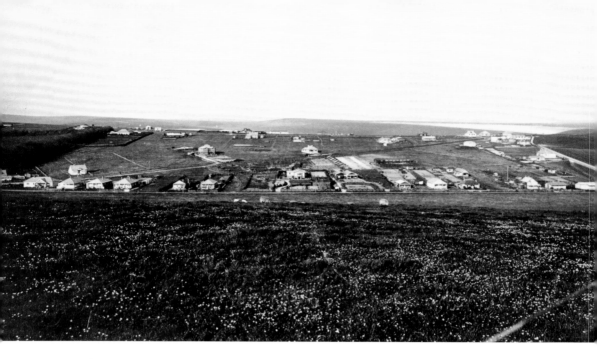

Homes along Greenways

The residential development of Ovingdean started in 1919 when the Long Hill Estate was sold off in plots. The Grange Estate, consisting of the field formerly known as 'Southlaine' (bounded by what are now Longhill Road, Beacon Hill, Greenways and Ovingdean Hall) was similarly sold two years later, although it had changed hands more than once before the war. It was laid out as exactly 100 plots, mostly of 40-foot frontages. By 1928-29 about seventeen houses had been built along the old 'Greenway Bottom' and, by around 1930, this was the first road to be full of houses.

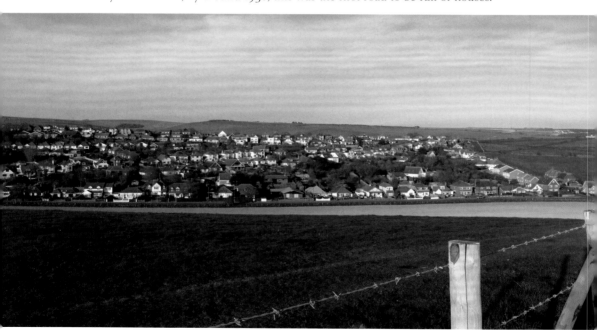

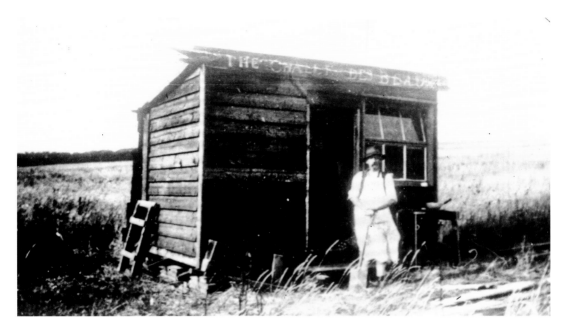

The Grange Estate

William Henry Beaumont, plotland pioneer (1857-1941), outside 'The Chalet de Beaumont'! He bought a plot on the Estate for £50 in 1920 and built the first house in the Ovingdean Road/Ainsworth Avenue/Beacon Hill segment. Caravans and old railway carriages were often used as homes at this time. Stella de St Paer (Buckland), a child in the 1920s, provided this author with a hand-drawn map showing a double-decker bus near the church being used as a dwelling ... For her further memories, see pages 92 and 93. The picture below of Beaumont's former house on Greenways, not far from the junction with Beacon Hill, dates from 1980. It was demolished in 1984.

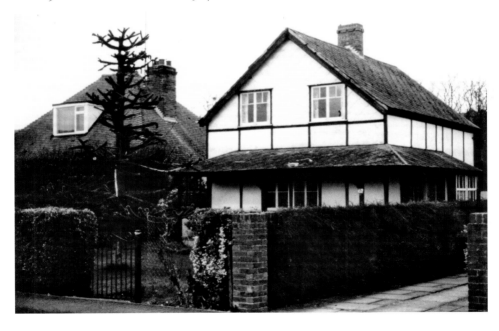

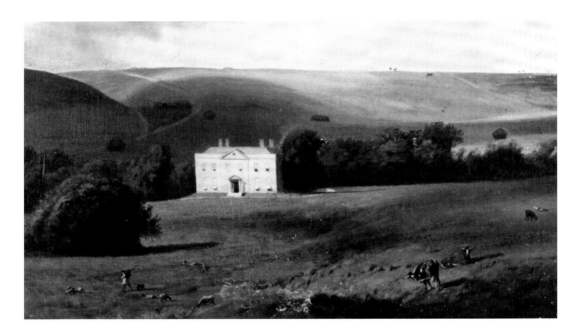

Ovingdean Hall

Ovingdean Hall was built in 1792 by Nathaniel Kemp, the father of Charles Eamer Kempe (1837-1907, renowned for his stained-glass windows) and the uncle of Thomas Read Kemp of Kemp Town fame. After Nathaniel's death in 1843 aged eighty-three, the family left Ovingdean and the house was let until 1858. It was subsequently occupied by Elliot MacNaghten until 1888 then opened as a preparatory school. Purchased in 1945 by the Brighton Institution for the Deaf and Dumb, the property became Ovingdean Hall School, a secondary school for pupils with a wide range of hearing impairment. Regrettably, this closed due to falling pupil numbers in late July 2010.

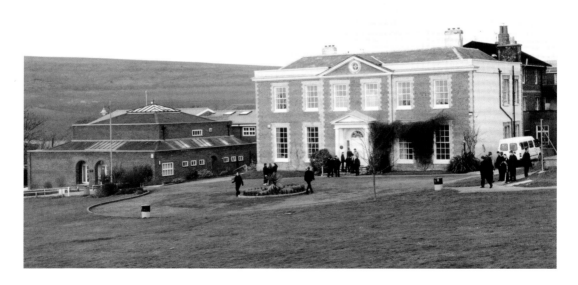

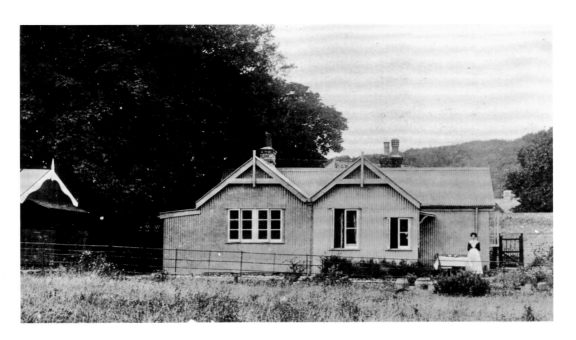

From Tin Bungalow to Café

The corrugated tin bungalow shown above was located on the west side of Greenways and built for village schoolmistress Miss Mary Genner (sometimes spelled 'Jenner'), recorded as living in 'School Cottage', presumably this building, in 1903 and 1904. The school closed in 1907. In 1918, the property was being rented by Mrs Mary Field, widow of a priest and formerly of Rectory Cottage. Her daughter, Cecily Hilda, had married Ovingdean's rector, the Revd Frederick West Anderson, in 1916 and the couple had moved to Hove in the following year. The premises which replaced the bungalow became the popular *Vienna Café*, managed by an Austrian lady, Mrs Mimi Brown. A residence named *Field End* (built 1976) now occupies the site.

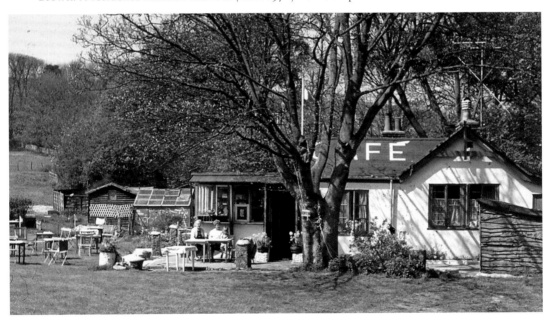

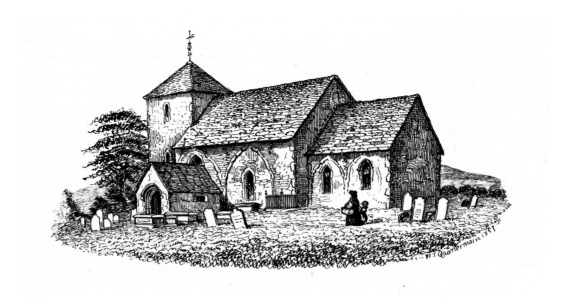

St Wulfran's Church (1)

Standing a short distance west of Greenways is the eleventh century flint church of St Wulfran's, seen here looking north-west in a sketch of 1851 by W. T. Quartermain. A tower was built in around 1216 and a chapel and vestry were added in 1907 and 1983 respectively. 'Time', wrote the historical novelist Harrison Ainsworth, 'has dealt kindly with it, and ... only added to its beauty' – a beauty evident in the accompanying photograph by the late David Baker. Alfred Noyes, who lived for a time in nearby Rottingdean, wrote a poem full of atmosphere describing a visit to it.

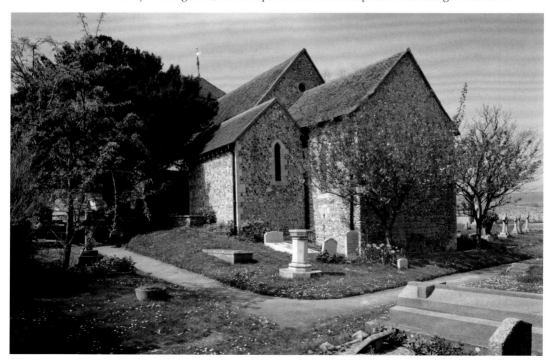

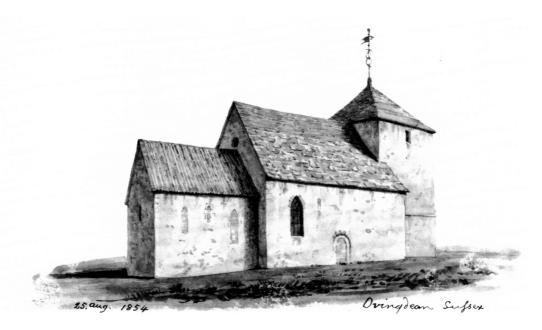

25. aug. 1854

Ovingdean Sussex

St Wulfran's Church (2)

An 1854 sketch by the Revd A. Hussey. The vestry added in 1983 blends in perfectly with the original building. On the extreme right of the picture below is the tomb of the Jex-Blake family. Sophia (1840-1912), one of the first women doctors, was the subject of a play, *Sophia*, by Bridget Biagi, performed in the village in May 1999. The tomb of Magnus Volk and the vault of the landowning Beard family are to be found in the churchyard, which was extended in the early 1950s and in 1989.

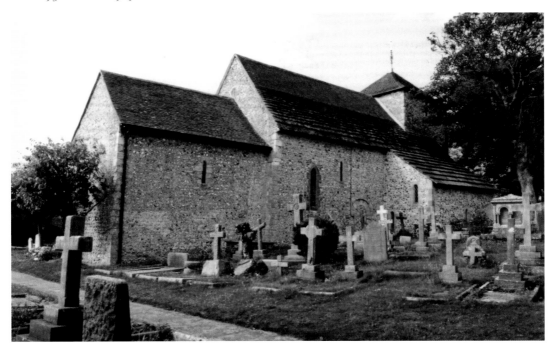

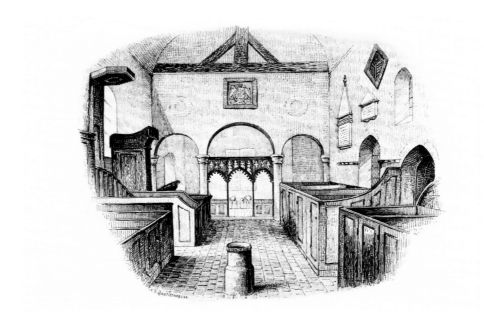

St Wulfran's Church (3)

The church interior as drawn in 1850 (also by Quartermain), showing box pews replaced by modern pews in 1865 and the font when it stood in the centre of the aisle. The fourteenth century rood screen was installed behind the altar in 1977. Church restoration took place in 1865-67 and, as a thank-offering for the work, Charles Eamer Kempe (1837-1907), cousin of Thomas Read Kemp, designed, executed and put in position the chancel ceiling, which was itself restored in 2005 at a cost of approximately £32,000. Kempe also designed the rood on the wall and was responsible for eleven of the thirteen exquisite stained-glass windows.

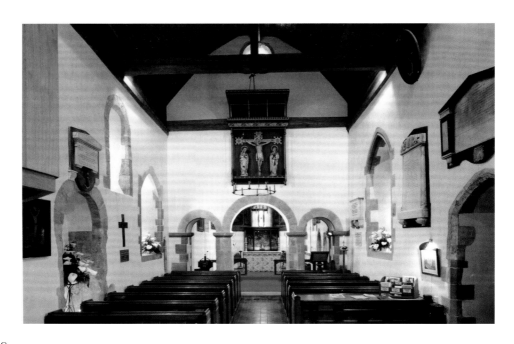

The Grange and Grange Farm (1)

Ovingdean Grange from the Cowstall painted by R. Jameson in 1933. The cowstall, today a residence in Beacon Court, had standings for forty-eight cows. Their feed included brewery grains, collected in the early days by horse and cart from Black Rock, Kemp Town and Tamplin's Breweries.

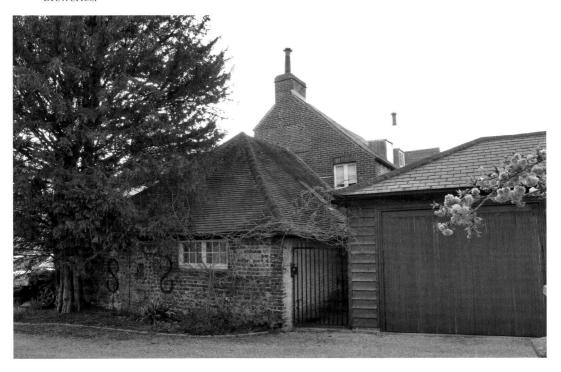

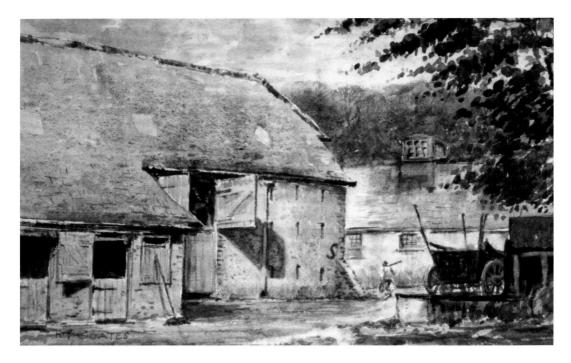

The Grange and Grange Farm (2)

The threshing barn and cowstall as depicted by H. Fenwicke Coates. By 1980, the tenant farmer, Frank Masefield Baker of Ovingdean Grange, had prevailed on Brighton Council to build a new farm just outside the village's 'North Gate'. All the old buildings of Grange Farm and Upper Farm were sold to developers, including this site (in 1983), renamed Beacon Court. In around 1895, another tenant farmer resident in the Grange, William Cowley (centre), had this splendid picture taken of himself with his farm hands. His late father, Henry, had taken over Ovingdean Manor Farm in 1877, when already farming at Black Rock, and had moved from there to the Grange between 1882 and 1884.

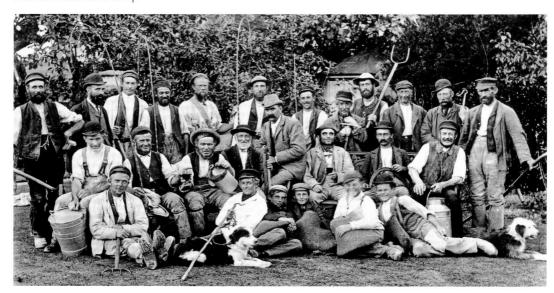

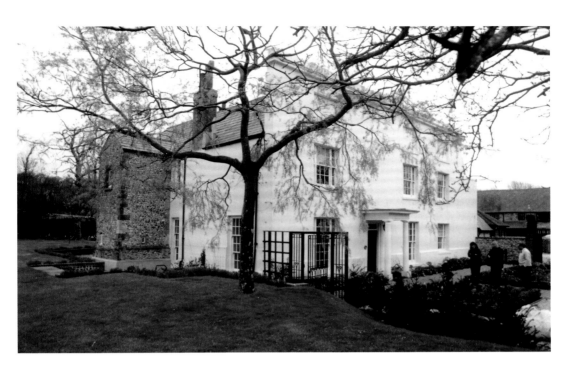

The Grange and Grange Farm (3)

This residence has been immortalised in William Harrison Ainsworth's historical novel, *Ovingdean Grange*, of 1860 in which the house contained a hiding place used by Charles II when escaping from Cromwell after the Battle of Worcester in 1651 (although the King actually stayed at the George Inn, Brighton, and never visited Ovingdean). Beacon Court can be seen on the far right. Below, the gardens are being enjoyed by the resident Cowley family for croquet in the late 1880s/early 1890s. Henry Cowley, second from left, died in 1893.

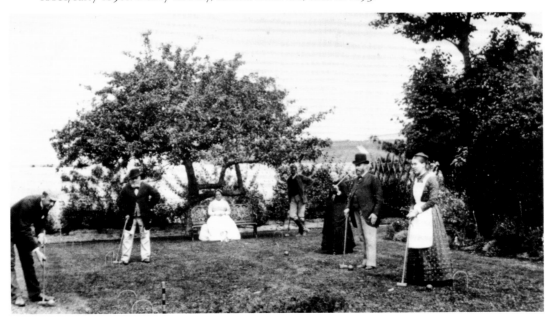

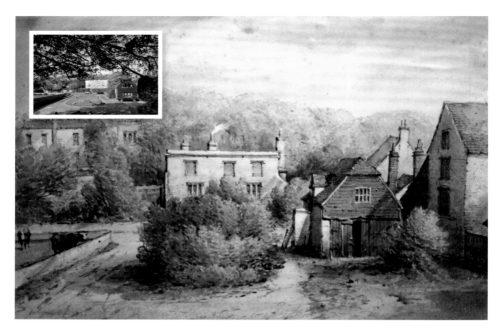

The Grange and Grange Farm (4)

This fine study of the Grange and environs dates from 1910 and was a wedding present to George Drake and Eva Cowley, the eldest daughter of William Arthur and Lilly Cowley. The couple married on 4 May 1910, the occasion being captured in the photograph below. In the foreground of the painting stand the lilacs planted by the Cowley family and known by villagers as 'The Clomp'. They were removed in 1930. In the following year, the tithe barn seen on the far right was converted to a dwelling, while the granary between it and the shrubs has since also become a residence.

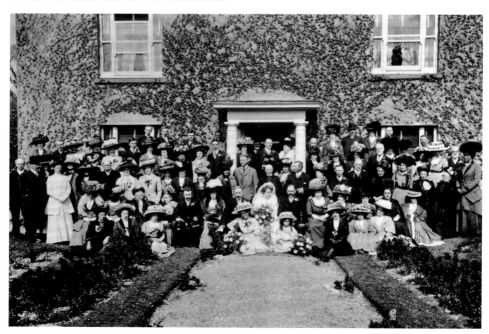

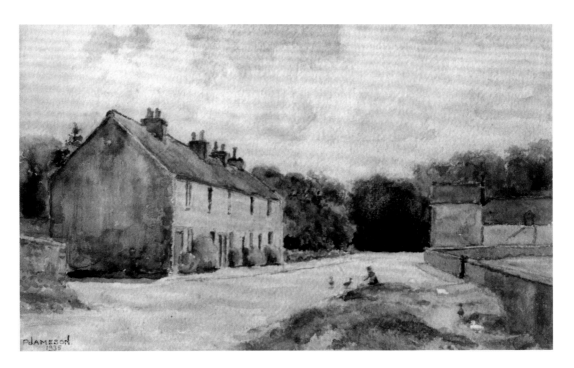

Peartree Cottages and Greenways Corner

This location was formerly known to locals as Hollands Corner due to one of the cottages being occupied by the Hollands family. The five dwellings, attractively depicted in this 1935 painting by P. Jameson, were named Peartree Cottages after an espaliered pear tree against the wall of the southernmost cottage and are thought to have dated from the early nineteenth century. They were demolished in 1934/35 for road widening and the homes were replaced by borough housing.

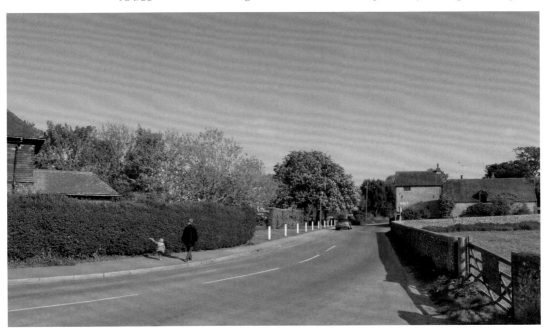

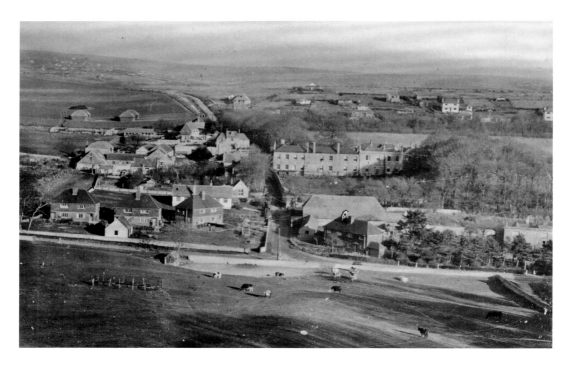

The Pond and Hollands Corner

Cattle still graze in the field (Hog Croft) opposite Ovingdean Road but the dew pond adjacent to the flint wall was filled in shortly after the war. Trees replace Peartree Cottages on the right but one surviving constant is the old gabled smithy in the left foreground, which now serves as a garage. Ovingdean Hall School dominates the right half of the picture and its position relative to the Grange is clearly evident. A cow in the recent picture is, uncharacteristically, taking a rest.

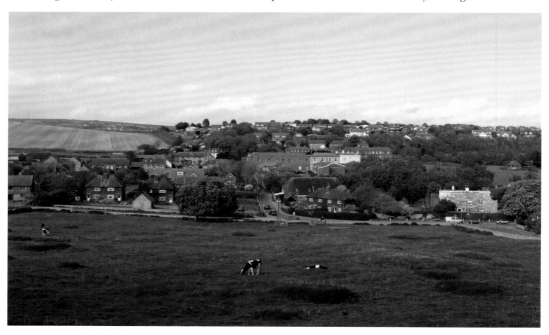

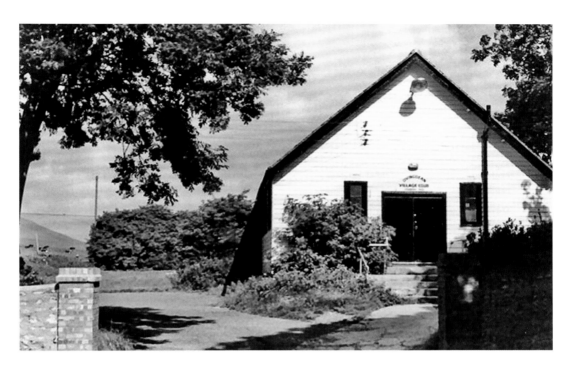

The Village Hall (formerly Club)

The first Village Hall was built in 1932 by a local man, Bill Davis, on land leased from Brighton Corporation. A trustee group of residents had been formed for the venture, which was financed by a £300 loan and local fundraising. Although unlicensed, the premises proved extremely popular. A putting green laid out behind the hall was likewise much enjoyed. In 1986 a new hall replaced the old, which was by then in a poor state.

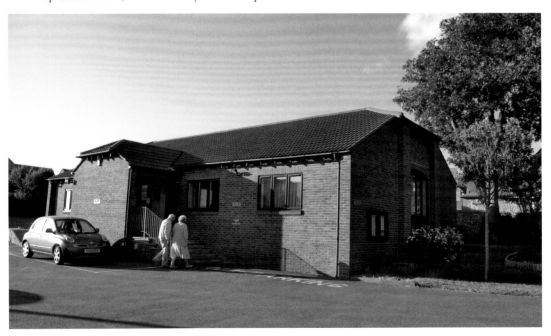

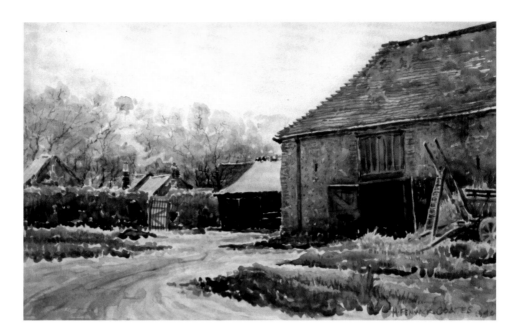

The Shearing Barn

Opposite the Village Hall stands the former shearing barn of Ovingdean (Grange) Farm, painted by H. Fenwick Coates in 1940. Left of it stands the cart lodge, long since demolished. Thought to date from the eighteenth century, the barn was acquired by Brighton Corporation in 1912 as part of the manor estate and sold off in 1979. A developer later converted it to today's residence, *The Olde Barn*. The dwellings on the other side of the gated hedge, adjoining the grounds of the Grange, have likewise been redeveloped.

Inset: The barn's frontage to Ovingdean Road, showing *The Hames*, another former barn. It was used for livestock. The long building across the road is the Village Hall.

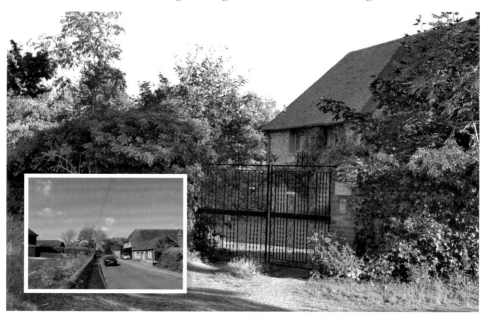

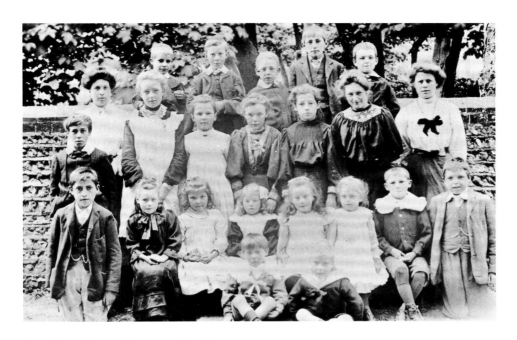

The Church Room/Nursery School

Prior to the village hall being built, social activities in Ovingdean were held at the 'Church Room' in Ovingdean Road. This was built in 1873 as a 'National School' but closed due to dwindling pupil numbers in 1907. The above picture, showing the head teacher, Miss Genner, with her charges was taken just before closure. In 1993, the privately-owned Ovingdean Nursery School opened on the premises. The modern photograph was taken in early 2000 to accompany a feature in the local *Argus* newspaper by this author on schooling in the village.

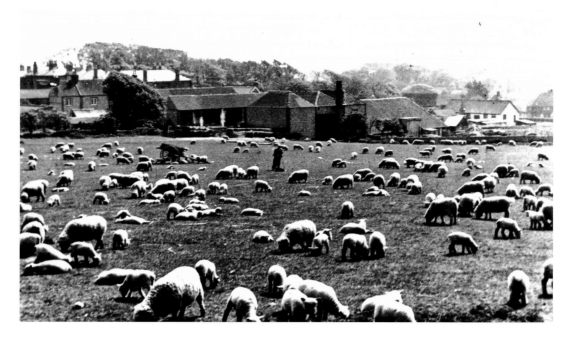

Behind Upper Farm Buildings

Sheep-farming was important on Ovingdean's farms. A large flock of young and old animals peacefully grazes on land north of Ovingdean Road. In the distance on the right can be seen the (old) Village Hall while in the central background are various buildings of Upper Farm, all now sympathetically converted to desirable dwellings. Upper Farm was originally Ovingdean House Farm and contained some ten buildings. It was merged in more recent times with Ovingdean (Grange) Farm.

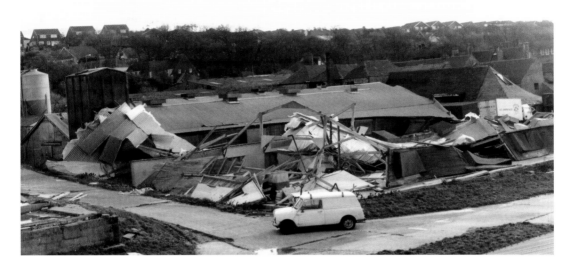

Hurricane Damage and a Baling Machine

Here, with a dramatic foreground, the Upper Farm buildings are seen in 1987 from the north-west. Ovingdean Hall Farm stood on land bought from Ovingdean Hall School in 1944 and was used for poultryfarming. Production was intensified in 1960 by the then owner, Charles C. Curwin, who erected large battery farming buildings. Egg production was transferred in 1970 to his complex in Sayers Common, although chicken-rearing continued successfully in Ovingdean until nature intervened. Below is a classic study by resident and keen photographer Percy Luck (*d.* 1965, aged eighty-five) of farm work being carried out north of Ovingdean Road.

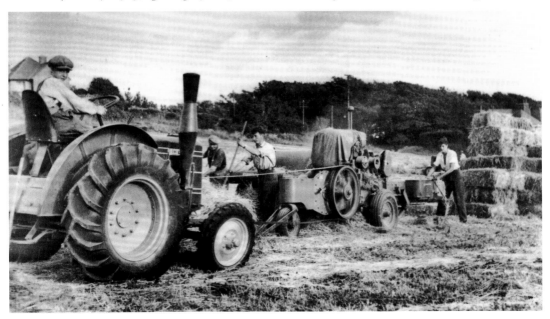

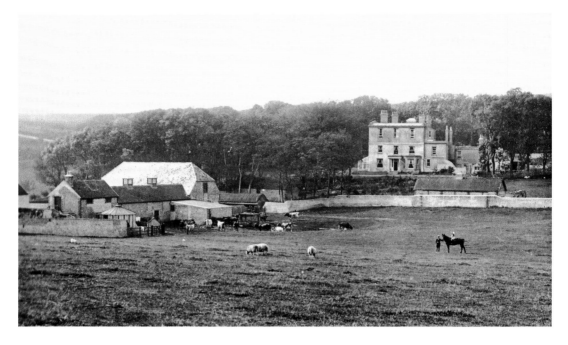

Woodingdean Farm and Woodingdean House

The above picture, dating probably from the early 1920s, shows Woodingdean (originally 'Woodendean') Farm and its buildings and Woodendean House of 1832-38. Much of today's extensive suburb of Woodingdean stands on land originally attached to this farm, whose buildings have now themselves been converted into dwellings. Noted later owners/occupiers of the mansion, which from around 1888 was styled Woodingdean House and from 1939 Woodland Grange until demolition in 1965, were Max Miller, Violet Van der Elst and, briefly during the war, Emperor Haile Selassie of Ethiopia.

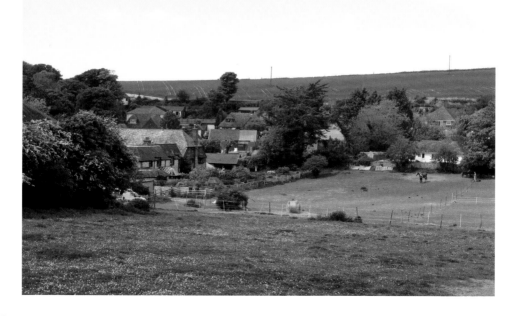

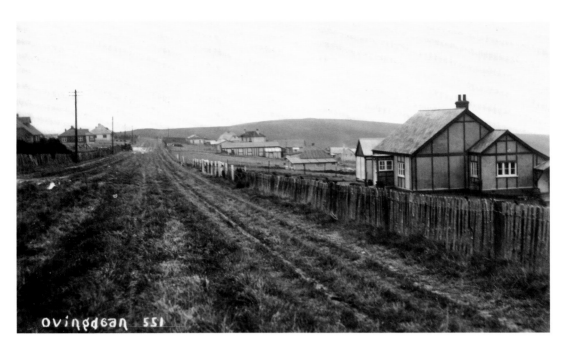

Ovingdean 551

Longhill Road – a Major Residential Thoroughfare

The Long Hill Estate was laid out in around 1919 as seventeen plots north-east of what is now Longhill Road. This roadway had previously been a field boundary and important pathway dividing arable land from pasture. Eleven of the plots were up to five acres each, with frontages of up to 580 feet (177m) along Longhill Road, and there were a further six plots facing Ovingdean Road up to Wanderdown Road. By 1928-29 about half the plots (often reduced in size) fronting Longhill Road had been built on and some eighteen houses existed. Below, Ovingdean's hourly bus approaches from the south.

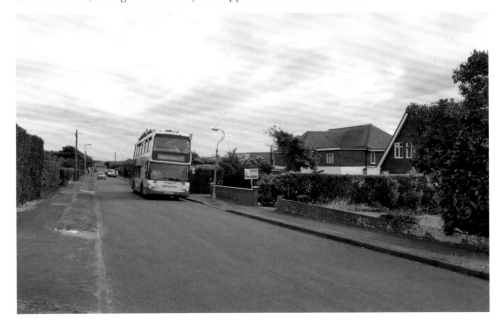

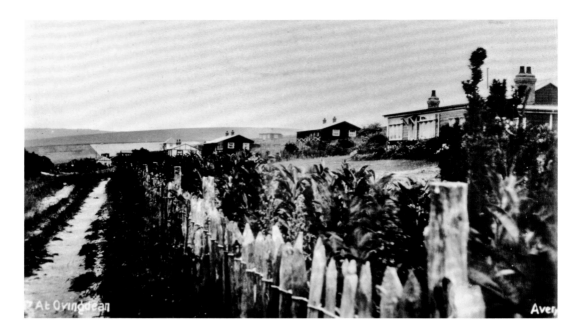

Longhill Road looking North-West

This 1920s view, published as a postcard by Avery's of Brighton, clearly illustrates the first-generation housing in Ovingdean. Stella De St Paer (Buckland, *b.* 1920) provided this author with a nine-page unpublished memoir dated February 2001 and entitled *Ovingdean – From 1927*. Her aunts, the Misses Wyatt, retired to the *The Little House* in Longhill Road that year and Stella spent the school holidays with them. Among her many memories were the railway carriages beyond the village stores, the 'occasional ramshackle bus into Brighton' and various makeshift dwellings, including Miss Gleeson's blue gypsy caravan, which was 'palatial compared with Nance Begg's horse-box' …

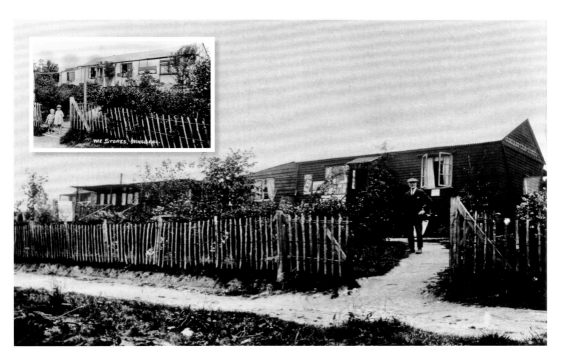

The Stores

Ernest Churchman (pictured), his much younger wife, Ethel, and their baby, Phyllis, moved to this accommodation in Ovingdean from Hove in 1920. In the following year, Ethel turned it into 'Churchman's Stores' and soon also started the 'Sunnyside' poultry farm. In the inset picture, two of the three Churchman children are standing outside the revamped stores, which stocked 'a large variety of stores, had an off-licence and did a newspaper delivery' (Stella De St Paer). By 1930, the widowed Ethel had sold the business and moved into the railway carriage next door with her children. Today the popular and important stores stands on the same site as its predecessors.

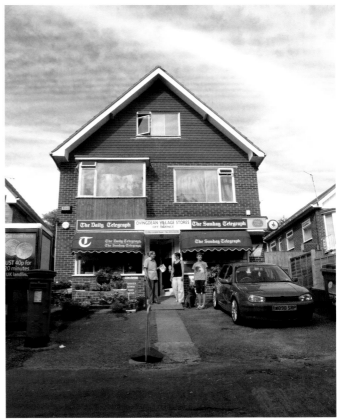

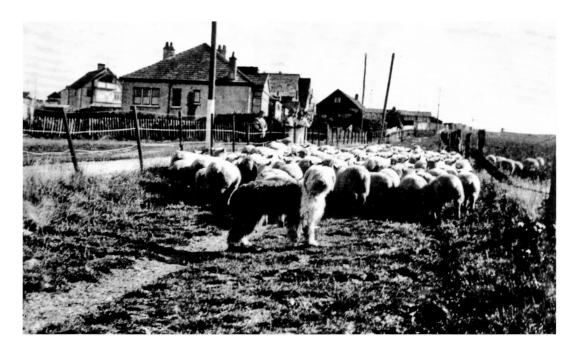

On Beacon Hill

Our circular tour of Ovingdean ends on Beacon Hill, seen here with sheep being driven on a parallel trackway by Ben Dudeney's Old English Sheepdog 'Old Nell'. The flock was owned by Farmer McCallum of Greenway Cottages, which date from 1892 and are partly visible on the right hand side of the lower picture. By 1928-29, only a handful of houses had been built on this unmade road, which marked the parish boundary with Rottingdean. In 1934 it was a dedicated highway about 10 feet in width which was about to be widened to 30 feet. This was presumably when it was named 'Beacon Hill'.

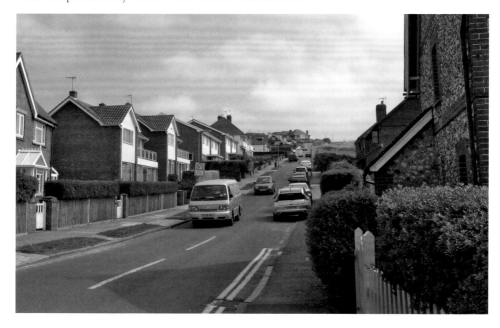

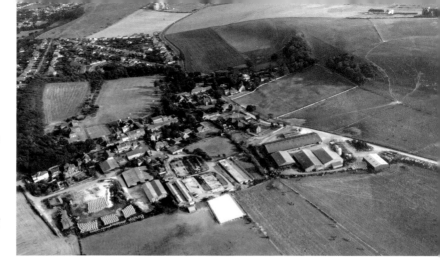

Ovingdean Panorama
Longhill Road is on the left beyond the trees, St Dunstan's stands left of centre on the horizon and Greenways curves away from that building right into the village. A farm road, right, leads off from Greenways to the north-west.

Acknowledgements

I am deeply indebted to the following individuals who readily assisted me with their local knowledge and/or images. Some helped in far greater measure than others and they know who they are. Yet without the assistance of all of them, this volume could not have been produced:

Kevin Bacon (Curator of Photographs, Royal Pavilion and Museums), John Baker, Faith Barton, Peter Booth, Brighton Racecourse, Derek Burns, Trevor Cox, Sue Craig, Bob Curtis, Joy Cuthbertson, John G. Davies, Barry Davis, Jennifer Drury (My Brighton and Hove website), Ernie Dudeney, Andy Embling, June Evans (Friends of Sheepcote Valley), Alison Eyre (Moulsecoomb Public Library), Fred Farley, Harry Gaston, Ian Gledhill, Sara Jane Glendinning, Beverley Green (Image Reproduction Officer, Royal Pavilion and Museums), Roberta Hazan (St Dunstan's Archives, London), Joyce Heater (Archivist, Brighton College), Peter Hill, Leoframes, Chris Horlock, Irene Jackman, Robert Jeeves, Cliff Holford Keenan, Alan Keys (Photographic Restoration Services, Telscombe Cliffs), Tricia Leonard, David McElvenny (Roedean School), Alan McFaden, Brenda McKenna, Selma Montford, Steve Myall, Fred Netley, Gwen O'Sullivan, Joy and Steve Rogers, David and Shirley Ross, Roger Rowell, Bill Sibbey, Brian Simpson (Savebrighton campaign), Rob Smith, Sheila Stacey, Molly Styles, Jackie Sullivan (Archivist, Roedean School), Eric Tyler, Maria White, Richard Whiting, Fr Andrew Woodward and Chris Wrapson. To anyone inadvertently omitted, my deepest apologies.

I am especially grateful to John G. Davies for reviewing the Ovingdean section and thank my wife, Caroline, for help with decisions on certain pictures.

I should like to thank the following public/commercial providers of images, including the Royal Pavilion & Museums (Brighton & Hove) re Pages 22 (upper), 33 (upper and lower) and 35 (upper), Denny Rowland re Pages 20 (upper) and 36 (upper), Connors Brighton re Page 45 (lower) and Chris Lord (Page 49, inset). Page 60 (lower) from www.savebrighton.com by Desmond Winchester (2006) is reproduced by permission of the photographer and the savebrighton campaign.

I appreciate also the loans of pictures from the following individuals and collectors: Henry Smith and Steve Myall (early Brighton prints), Sue Craig and Fred Netley (East Brighton images), Peter Mercer and Tricia Leonard (images of the early Marina) and Daphne Turner (who kindly made available the late David Baker's collection of Ovingdean pictures on which the Ovingdean section is largely based).

Bibliography

Ainsworth, Harrison *Ovingdean Grange*, London, Herbert Jenkins Ltd, nd.

Bangs, David *Whitehawk Hill*, self–published, Brighton 2004.

Argus, The Online newspaper archive from 1998 and current features/news items.

Carder, Timothy *The Encyclopaedia of Brighton*, Lewes: East Sussex County Libraries, 1990.

Coates, Richard *A Place–Name History of the Parishes of Rottingdean and Ovingdean in Sussex (including Woodingdean and Saltdean)*, Nottingham: English Place–Name Society, 2010.

Dale, Antony *Fashionable Brighton, 1820–1860*, Newcastle upon Tyne, Oriel Press, 1967.

Dale, Antony & Gray, James S. *Brighton Old And New*, EP Publishing Ltd, Wakefield, 1976.

Davies, John G. *A Historical Gazetteer of Ovingdean Ecclesiastical Parish* (Typescript 1989) and other papers.

Dawes, H. T. (SIAS) *The Windmills and Millers of Brighton*, Brighton, Lewis Cohen Urban Studies Centre/Sussex Industrial Archaeology Society, 1987.

Drury, Jennifer (Ed.) *In Living Memory – An Oral History of Ovingdean Village*, Ovingdean Millennium Association Community Publishing Group, 2000.

Dunn, Ruby *Moulsecoomb Days*, QueenSpark Books, Brighton, 1990.

Elleray, D. Robert *Brighton – A Pictorial History*, Phillimore & Co, Chichester, 1987.

Ford, John and Jill *Images of Brighton*, Saint Helena Press, Richmond-upon-Thames, 1981.

Heater, Joyce *Brighton College*, Tempus Publishing Ltd, Stroud, 2007.

Hollingdale, Eileen *Old Brighton*, George Nobbs Publishing Ltd, Norwich, 1979.

Horlock, Christopher *Brighton & Hove Then and Now – Volume 1*, Seaford, S. B. Publications, 2001.

Horrobin, George *The History of Brighton Marina* (an unpublished record up to the opening in 1979), 1979.

Livingston, Helen *Brighton*, Frith Publishing (an imprint of Waterton Press Ltd, Salisbury), 1998.

Livingston, Helen *Brighton and Hove – Pictorial Memories* (Town and City Series), Waterton Press Ltd, Salisbury, 1998.

Mercer, Peter, with Holland, Douglas *The Hunns Mere Pit: The Story of Woodingdean and Balsdean*, Lewes, The Book Guild, 1993

Middleton, Judy *Brighton and Hove – A Portrait in Old Picture Postcards, Vol. 1*, S. B. Publications, Market Drayton, 1991.

Middleton, Judy *Brighton Through Time*, Amberley Publishing, Stroud, 2009.

Netley, Fred *Holy Oak: A History of Whitehawk and Manor Farm, 1934–1974*, Phoenix Press, Brighton, 2002.

Roles, John & Beevers, David *A Pictorial History of Brighton*, The Breedon Books Publishing Co Ltd, Derby, 1993.

Shipley, Berys J. M. *The Lost Churches of Brighton and Hove*, Optimus Books Ltd, Worthing, 2001.

Various contributors *The Story of Queen's Park*, Brighton, Brighton Town Press, Brighton, 2009.

Various contributors *The Landscape Book of Brighton Prints*, Brighton Books Publishing, Brighton, 2005.

Websites
Space precludes reference to the many consulted but two cannot be omitted, namely:
www.mybrightonandhove.org.uk
www.bygones.org.uk